NAVAJO WEAVING

STUDIES IN AMERICAN INDIAN ART

The publication of this book was made possible by generous support from the Brown Foundation.

NAVAJO WEAVING

Three Centuries of Change

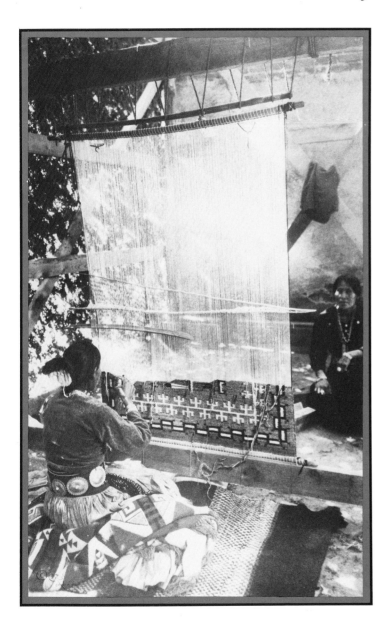

KATE PECK KENT

with a Catalogue of the School of American Research Collection

SCHOOL OF AMERICAN RESEARCH PRESS : SANTA FE, NEW MEXICO

SCHOOL OF AMERICAN RESEARCH PRESS
Post Office Box 2188
Santa Fe, New Mexico 87504

EDITORS: Laura de la Torre Bueno, Jane Kepp
PHOTOGRAPHER: Fred Barden
ILLUSTRATOR: Arminta Neal
DESIGNERS: Linnea Gentry, Deborah Flynn
TYPOGRAPHER: Casa Sin Nombre
PRINTER: Paragon Press

DISTRIBUTED BY UNIVERSITY OF WASHINGTON PRESS

Library of Congress Cataloging in Publication Data

Kent, Kate Peck.
 Navajo weaving.

 (Studies in American Indian art)
 Bibliography: p.
 Includes index.
 1. Navajo Indians—Textile industry and fabrics—History. 2. Indians of North America—
Southwest, New—Textile industry and fabrics—History. 3. Navajo Indians—Textile industry
and fabrics—Catalogs. 4. Indians of North America—Southwest, New—Textile Industry and
fabrics—Catalogs. 5. School of American Research (Santa Fe, N.M.)—Catalogs. I. School of
American Research (Santa Fe, N.M.) II. Title. III. Series.
E99.N3K39 1985 746.1′4′08997 85-10875
ISBN 0-933452-12-8
ISBN 0-933452-13-6 (pbk.)

Frontispiece. Navajo woman weaving a rug, probably at Ganado, Arizona, in the 1920s. Her
costume, traditional since the early 1900s, consists of velveteen blouse and full skirt, silver
concho belt worn over a warp-patterned belt, high-topped moccasins, and Pendleton blanket.
(Courtesy Ruby Schultz, photo by Cross Studio.)

Contents

Illustrations

Frontispiece. Navajo woman weaving a rug, probably at Ganado, Arizona, in the 1920s.

Plates

Figures

Preface

Research for this book was carried out under a grant from the National Endowment for the Arts. The original intent of the grant was to allow analysis of the School of American Research collection of southwestern textiles as a whole, and to publish the findings in a single catalogue. As the study progressed, it became clear that the extent of the holdings would require a volume of unwieldy proportions, even if it contained a bare minimum of substantive information. Thus the decision was made to describe Pueblo textiles in one monograph (Kent 1983c) and Navajo weavings in a separate book. Grants from the Brown Foundation and the William H. and Mattie Wattis Harris Foundation have aided materially in its publication.

Most of the textiles illustrated in this book are from the collection of the School of American Research. Some originally were illustrated in the series of pamphlets on Navajo textiles written in the 1930s by the late Harry P. Mera (republished in book form in 1947), and are probably still thought of by many readers as type specimens. The pieces illustrated in color were carefully selected to show the full range of shades found in Navajo textiles: presynthetic red (cochineal and lac), bright anilines, vegetal indigo, natural plant dyes, and so forth. All the Navajo textiles in the School's collection are listed in the appendix, with detailed descriptions given for the pieces illustrated in this book.

The School of American Research collection of more than four hundred Navajo textiles was built up by purchase through the Indian Arts Fund beginning in the early 1920s, and by gifts from many generous patrons over the years. It was carefully maintained and recorded by Harry Mera and Betty

Toulouse at the Laboratory of Anthropology, Museum of New Mexico, until housed in the School's Indian Arts Research Center in 1976.

I would like to thank Douglas W. Schwartz, president of the School of American Research, and the staff of the Indian Arts Research Center, particularly Barbara Stanislawski and Michael Hering, for facilitating my work. Laura de la Torre Bueno and Jane Kepp gave every assistance in preparing the text for publication. The excellent photographs of items in the School's collections were taken by Fred Barden, unless the caption notes otherwise, and I thank Deborah Flynn for her fine close-up photographs. Line drawings are the work of Arminta Neal, and the map was prepared by Carol Cooperrider. Anne Peacocke typed the manuscript, and Claudia Hubbard helped compile the appendix.

Joe Ben Wheat gave generously of information, much of it unpublished, which he has amassed through years of research on Navajo textiles. Marian E. Rodee helped in the dating of early-twentieth-century rugs, and Ann Hedlund permitted use of her doctoral dissertation for valuable data on contemporary weavers. Dyes were analyzed by David Wenger of the University of Colorado Health Science Center. Stanley M. Hordes, state historian at the New Mexico State Records Center and Archives, drew my attention to the value of court cases as resources for ethnographic data. Information on yei blankets was provided by Susan McGreevy. My thanks to these colleagues and to many others whose interest in and enthusiasm for Navajo weaving has reinforced my own.

NAVAJO WEAVING

Introduction

Navajo weaving has captured the imagination of many enthusiasts, not only for its aesthetic qualities—its variety of design and general excellence of technique—but also because its stylistic changes through time so faithfully mirror the social, economic, and political history of the Navajo people. It is as though the women wove their life experiences into their textiles, giving us insights into their changing world.

Navajos say they learned to weave from Spider Woman on a loom constructed according to directions given them by Spider Man. A more mundane view is that weaving as practiced by the Navajos is an eclectic art, learned from the Pueblo Indians in the mid-seventeenth century and reflecting both Pueblo and Spanish clothing styles and design preferences for the next 150 years. By the late 1700s, commercial European and Mexican trade cloth, which could be raveled for red yarns, modified the appearance of some Navajo textiles; and a few decades later, variously colored commercial yarns and strong Mexican influence in the form of the Saltillo design style changed them still further. Since about 1850, the major agent of change has been Anglo-Americans, who not only introduced bright aniline dyes but also, by furnishing ready-made clothing and commercial cloth, lessened the Navajos' need for their own loom products and turned the weavers towards an off-reservation market. Shortly before 1900, Anglo-Americans fostered radically new design motifs to be used on rugs rather than traditional blankets.

Navajo weavings may be classified for descriptive purposes under three major stylistic periods: the Classic, 1650 to 1865; the Transition, 1865 to 1895; and the Rug, 1895 to the present. These terms were first proposed by Charles A. Amsden in 1934; I have modified his opening and closing dates in some cases so that they correlate with significant historical events affecting the Navajo people.

Throughout the Classic period, Navajo weavers directed much of their time and energy toward producing clothing for their own people. They wove woolen articles very similar to those that the Pueblo Indians had designed and made of cotton long before the coming of the Spaniards. Outstanding among these were mantas—rectangular blankets wider, measured along the wefts, than they are long—which were worn as wraparound dresses by women and as shoulder robes by both sexes. The Navajos also made tuniclike shirts, breechcloths, narrow hair ties, and garters for men, and warp-patterned belts for both men and women. By 1700, Navajos as well as Pueblos were probably weaving wool serapes, or Spanish-style blankets longer, measured along the warps, than they are wide. The shape, the use of wool yarns and indigo dye, and probably the common pattern of simple stripes all resulted from Spanish influence.

Surplus products of the Navajo loom, particularly mantas and serapes, gained increasing importance in trade with Pueblos, other Indians, and Spaniards from 1700 to the late 1800s. With the opening of the Santa Fe Trail in 1821, the market for Navajo blankets expanded still further to include Anglo-Americans. In the last years of the nineteenth century (that is, during the Transition period), the Navajos wove less clothing for themselves and more blankets and serapes for trade with their traditional customers and Anglos as well. With the conversion of blankets to rugs just before 1900, weaving became essentially market oriented, though saddle blankets were, and still are, made for local consumption.

There has never been a time in the long history of Navajo weaving when the artists were not aware of the needs of the marketplace nor failed to modify their work to some extent to suit the tastes of potential buyers. This flexibility, coupled with the introduction of design ideas from other cultures and of new dyes and commercial yarns in a range of colors unknown to weavers of the eighteenth century, inevitably changed the appearance of Navajo textiles. Contemporary rugs bear little or no visual resemblance to textiles of the Classic period (compare plates 1 and 19, for example), and we

may not be able to find a single set of aesthetic principles expressed in all the various historical styles. The evolution of Navajo textile design cannot be understood, however, simply as a function of the myriad influences brought to bear on weavers over the centuries. It is the creative ways in which new ideas and materials were handled that will engage our attention. Navajo weavers struck a balance between eclecticism and originality.

Early accounts of Navajo weaving were written by Letterman (1856), Matthews (1884, 1900), and Pepper (1923). However, Amsden was the first to publish a detailed history of the craft, in 1934 (revised edition 1949). Gladys A. Reichard's books (1934, 1936, 1939), appearing in the same decade as Amsden's, furnish vivid accounts of the lives of the weavers themselves and of their attitudes toward their work. Living with a Navajo family near Ganado for several summers and learning to weave from them, Dr. Reichard documented the ways in which herding sheep, processing wool, dyeing, and weaving fit into the Indians' traditional way of life. Innumerable short articles, exhibit catalogues, magazine issues, and handbooks have appeared in print since the 1930s (see, for example, *Arizona Highways*, September 1964, June 1974; Dutton 1961; H. L. James 1976; Kent 1961; Maxwell 1963; *Plateau*, vol. 52, 1981; Rodee 1977, 1981; Wheat 1974, 1976a). Most of these follow Amsden in describing weaving of the nineteenth and early twentieth centuries, adding new material to bring the history of textiles up to the date of publication. Navajo aesthetics, as expressed in weaving and other arts, have been discussed by Brody (1976), Hatcher (1974), Mills (1959), Witherspoon (1977), and others.

The exhaustive researches of Dr. Joe Ben Wheat over the last twenty years into documentary materials not previously consulted, as well as his careful analyses of hundreds of textiles in museums and private collections, have augmented, clarified, and in some instances corrected Amsden's original findings. Although Wheat's work is not yet published in full, two short articles (1977; Fisher and Wheat 1979) summarize his data on fibers, yarns, dyes, technical weave details, and design that have been applied in dating the Classic and Transition period blankets for this book. My own research on prehistoric and historic Pueblo textiles and Rio Grande Hispanic weaving (Kent 1957; 1965; 1966; 1983a; 1983b; 1983c), carried on since Amsden's publication, has also led to a clearer definition of the relationships between these traditions and Navajo weaving.

The origin and evolution of Navajo weaving from about 1650 to the

early 1980s, as recounted here, is quite well documented, but the story has by no means ended. Change continues as weavers experiment with new materials and new combinations of design motifs. Undoubtedly the principal motivation for the perseverence of weaving is monetary return, but the art is also cherished, as it might well be, by many Navajos as a distinguished product of their traditional culture.

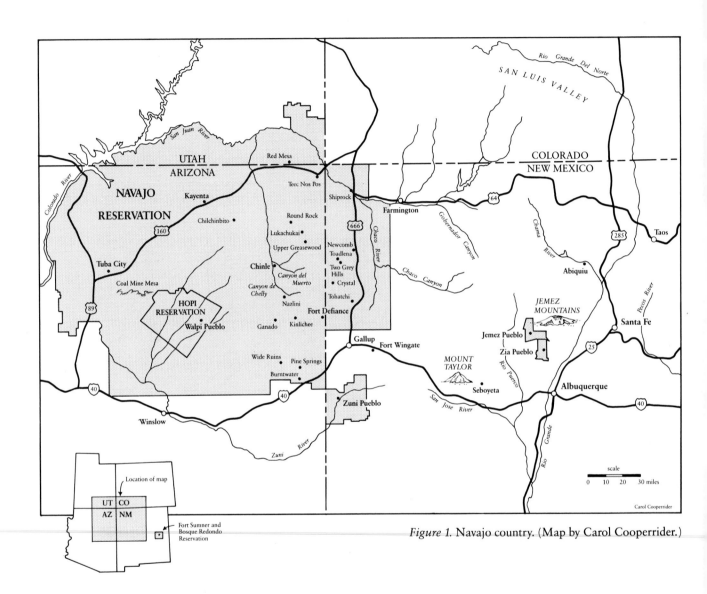

Figure 1. Navajo country. (Map by Carol Cooperrider.)

Navajo Weaving and Navajo History

I

Small bands of Athapaskan-speaking Indians from western Canada, wandering south through the Great Basin or perhaps along the High Plains just east of the Rocky Mountains, reached what is now northern New Mexico sometime between A.D. 1300 and 1500. They were essentially hunters and gatherers when they arrived, but they quickly adopted the agricultural techniques and crop plants of the Pueblo village dwellers they encountered in the Rio Grande Valley.

Settling first in the Chama River Valley from present-day Abiquiu north, they gradually spread farther west into the San Juan and Chaco basins and south along the western edge of the Jemez Mountains (fig. 1). Nomadic Indians who may have been Navajos were encountered near Mount Taylor by the Spanish explorer Espejo in 1582–83.

The Navajos' relations with their Pueblo neighbors and with the Spanish settlers (the first of whom had come from Mexico with Don Juan de Oñate in 1598) were far from friendly. In the 1600s, they made raids on every settlement from Taos south to Albuquerque, running off sheep and horses that had been brought into the Rio Grande Valley by the Spaniards, rifling Pueblo fields, and capturing both Pueblos and Spaniards to use as slaves. The Spaniards and Pueblos retaliated. For both sides, the desire for captives is said to have been the major cause of conflict (Brugge 1983:491). Hostilities, however, were suspended by mutual understanding during the trade fairs inaugurated by the Spaniards and on the occasion of certain Pueblo feast days, when Navajos brought game and buffalo hides to exchange for agricultural produce, textiles, metal knives, and other useful articles of Spanish or Pueblo manufacture.

The Spaniards failed to bring the Navajos under their control in the 1600s. Efforts to establish a mission among them to teach Christianity and a settled way of life were rejected out of hand, the Navajos preferring the freedom of their seminomadic existence (Hester 1962:91–92). For the settled Pueblo agriculturalists, the story was quite different: Spaniards forcibly subjugated village after village. Annual tributes of corn and cotton mantas were collected by mission and secular authorities alike, and Pueblo labor was exploited to work Spanish fields, herd Spanish sheep, knit wool socks for the use of settlers and for trade to Mexico, and weave woolen blankets. Many of the hard-pressed Pueblo people left their villages and moved in with Navajos on the northern and western frontiers, out of reach of Spanish rule. As the seventeenth century wore on, conflicts between Pueblos and Spaniards increased; finally, in 1680, the Pueblos united and drove their oppressors south down the Rio Grande Valley to El Paso del Norte.

It is quite likely that some Navajos had learned to weave as a result of interaction with Pueblo slaves or refugees before the rebellion, although there is no way of determining exactly where or when this may have occurred. Mixed Tewa-Athapaskan archaeological sites in the vicinity of Abiquiu, probably dating to the mid-1600s, contain quantities of sheep bones along with Tewa pottery, attesting to the fact that sheep and herding technology had reached Navajos in the Chama Valley by that time (Schaafsma 1978). Part of a wooden spindle whorl from one site suggests that they had knowledge of spinning, and it is possible the Tewas had also introduced the weaver's art to them. Or it could have been learned at Jemez, Zia, or some other pueblo with which the Navajos had close trade ties.

The Chaco Navajos had a tradition that weaving was taught to them by a Pueblo woman living among them as a slave (Brugge 1980:9); the reference is apparently to an event that took place between about 1675 and 1700. The woman's pueblo of origin is not recorded, but since—at least to the best of my knowledge—weaving was a man's art among the Pueblos except at Zuni, where both sexes wove, one might conclude she was from Zuni. Certain technical similarities between Navajo and Zuni textiles lend support to this assumption.

Whoever the instructors may have been, weaving probably became established as a woman's rather than a man's art among the Navajos because of the way sex roles were structured within their society. Men were engaged in raiding, trading, and hunting, which kept them on the move a good bit of

the time, leaving more sedentary home-based occupations such as craft work to women. Navajo women made coiled baskets, which may also have predisposed them to weaving. Certainly the tapestry patterns on the oldest surviving Navajo textiles, those of the 1700s and early 1800s, appear to have been adapted from basketry (fig. 2).

Whatever the status of weaving among the Navajos may have been before the Pueblo Revolt of 1680, there is no question of its importance after that event. Fearing reprisals should the Spaniards return, many Pueblos had left their homes and joined Navajos in the Gobernador Valley. Here the two peoples lived together so intimately that by the early 1700s they were genetically and culturally fused into a single entity. Weaving was an integral part of their hybrid culture.

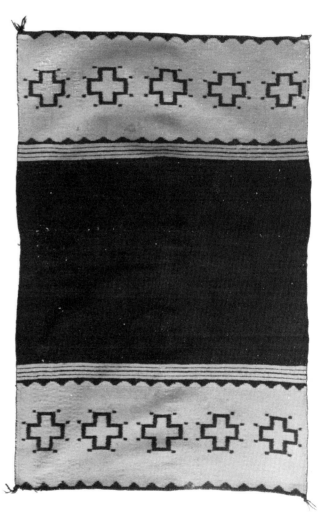

There is little doubt that the Pueblos' weaving had been "Hispanicized" prior to the time they taught their skills to the Navajos. That is, they had added to their indigenous weaving complex the use of wool and indigo dye. Besides their traditional manta (a wider-than-long wearing blanket), they wove blankets similar in shape to the long, narrow serapes of the Spaniards, some patterned in the blue-, black-, and white-striped design that was probably also a foreign introduction (plate 3). Evidence for this lies in textile fragments exhibiting these Hispanic characteristics, found in a room built in the late 1690s—about the time of the Spaniards' return—in the Hopi pueblo of Walpi.

The Navajos are described in Spanish reports from the early 1700s as growing and weaving cotton besides herding sheep and weaving woolen blankets, many of which they used in trade (Hill 1940:395–415). The cultivation and use of cotton apparently diminished in importance among them in the course of the century, although Josiah Gregg, writing in 1844 (1962:153), noted that Navajos "as well as the Moquis. . .are still distinguished for some exquisite styles of cotton textures [sic]." To my knowledge, the cotton blanket in the Harvey collection, which Wheat (1976a:24) dates to 1775–1825,

Figure 2. Navajo baskets with terraced patterns of the type transferred to Classic period dress borders and other textiles, as in the dress shown here. The cross with small "flags" at its corners is known as the Spider Woman cross. Baskets: *left,* SAR 1978-4-34; *right,* SAR B.248. Dress (one half): 1860–1870, 56″ x 36″, SAR T.25.

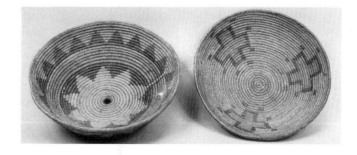

Figure 3. Handspun cotton blanket dating between 1775 and 1825. It has a natural creamy white ground and a design in natural dark brown cotton and raveled cochineal-dyed red yarns. 64" x 46". (Courtesy Fred Harvey Fine Arts Collection, Heard Museum, Phoenix, Arizona.)

is the sole surviving example of Navajo work in that fiber (fig. 3).

Throughout the 1700s, the Navajos expanded the trade network with Pueblos, Utes, Apaches, Comanches, and Spaniards in which their woolen blankets played a major role. Relatively peaceful relations between Navajos and Spaniards mark the years from 1720 to 1770, but both groups were subjected to increasingly severe raids by Utes and Comanches. These depredations pushed Navajo bands west to the Chuska Mountains and south to Cebolleta (now Seboyeta) and the Rio Puerco, where they clashed with Spanish settlers. Hostilities recommenced, culminating in the Spanish punitive expedition of 1804–5 that ended with the killing of a band of Navajo women, children, and old men. The group was hiding in what came to be known as "Massacre Cave," a shallow alcove in the rock wall of Canyon del Muerto in northeastern Arizona.

Following this incident, raiding diminished until 1821, when control of the Southwest passed from Spain to the newly autonomous Mexican government. Preoccupied with problems at home, that fledgling nation was unable to control the warring factions on its northern frontier. Navajo raids on settled communities again escalated, as did retaliatory engagements, and both sides kept people captured in these skirmishes as slaves. Paradoxically, the trade in Navajo blankets also increased in the 1820s. The Santa Fe Trail, opened in 1821, linked New Mexico to the central United States and furnished an additional outlet for weavings, as well as bringing new yarns to the weavers. Navajo blankets of the period were considered superior to those produced on treadle looms by Hispanic weavers in the Rio Grande villages and were coveted by Mexicans, Anglos, and Indians alike. Josiah Gregg (1962:153) reported in 1844 that the Navajos wove "a singular species of blanket, known as the *Sarape Navajo* which is of so close and dense a texture that it will frequently hold water almost equal to gum-elastic cloth. It is therefore highly prized for protection against the rains. Some of the finer qualities are often sold among the Mexicans as high as fifty or sixty dollars each."

The waterproof quality of Navajo blankets made them desirable to Plains Indians, too (fig. 4). William Boggs, a trader at Bent's Fort on the Arkansas River in 1844–45, told of seeing several hundred young Cheyenne women at a dance wearing their Navajo blankets, which he describes as "all alike" and patterned by white and black stripes about two inches wide (McNitt 1962:35; see also fig. 32).

Striped blankets were only one of the styles woven by Navajos at that time. Elaborately patterned serapes made in Mexico and imported into the northern Rio Grande Valley were affecting the designs of both Hispanic and Navajo weavers. This influence, coupled with the availability of brightly colored yarns whose like had not been known to Navajo weavers in the 1700s and very early 1800s, resulted in increasingly complex Navajo blanket patterns in the later part of the Classic period (plate 2).

The Southwest was ceded to the United States by Mexico in 1848, and with it came the "Navajo problem," a confusing mix of conflicts including Navajo raids on Spanish, Pueblo, and Anglo-American settlements as well as attempts by whites to gain possession of Navajo lands. A succession of treaties written and signed by United States authorities and various Navajo bands guaranteed an end to hostilities, but since no one treaty was binding on all Navajos, trouble continued. The United States Army staged a number of forays into Navajo country, and army posts were established at Fort Wingate and Fort Defiance in an effort to enforce peace. Finally, the federal government decided to place the Navajos with the Mescalero Apaches on a reservation at Bosque Redondo, near Fort Sumner in east-central New Mexico. Colonel Kit Carson led a contingent of soldiers into Navajo country in 1863. By destroying Navajo flocks and farms wherever he found them, leaving the people no subsistence base, Carson managed to round up some eight thousand Navajo men, women, and children for removal to Bosque Redondo (fig. 5).

For five years the Navajos endured captivity. During this time there were major changes in all aspects of their culture, not least in weaving. Army authorities issued commercial yarns to weavers as a substitute for the wool of their lost sheep. Included were cotton string and both natural- and aniline-dyed wool yarns in a variety of colors new to the Navajos. The Navajos' dependence on their own loom products for clothing lessened with the availability of commercial cloth and blankets. In 1867, four thousand blankets made on treadle looms by Hispanic weavers in the Rio Grande Valley were

Figure 4. Two Cheyenne women wearing Navajo blankets. The women had taken part in a scalp dance at Bent's Fort on August 7, 1845, celebrating a victory over the Pawnees; this was probably the same dance described by William Boggs. Watercolor by Lt. James W. Abert, U.S. Topographical Engineers (from Galvin 1970, courtesy John Galvin).

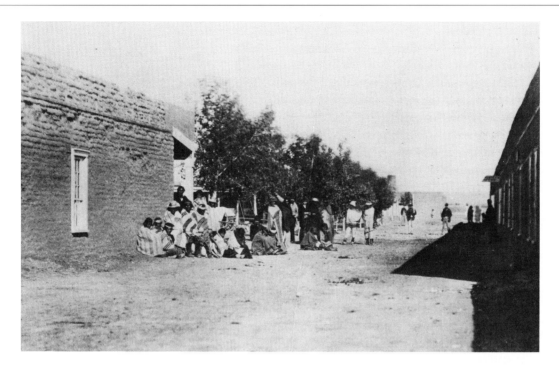

Figure 5. Navajo Indians under guard at Fort Sumner (Bosque Redondo), New Mexico, 1864–1868. Striped blankets are much in evidence. A man to the right of center wears what appears to be a white blanket with blue and red borders, the type called "maiden shawl" and generally associated with Pueblo people. (Courtesy U.S. Army Signal Corps Collections in the Museum of New Mexico, photo no. 28539.)

purchased for Navajo use (Wheat 1977:432). Some of these may have been patterned according to the Mexican Saltillo design system. If so, here was a direct influence on Navajo weavers that could help account for the shift from the terraced patterns of the Classic period to the serrate or diamond style that gained such importance after 1865 (compare plates 1 and 14).

It is generally held that Navajo women began at this time to relinquish their traditional blanket-dresses in favor of the American-style calico skirts and blouses that became their everyday costume in the late 1800s. Photographs of Navajo women taken at Bosque Redondo (fig. 6) do not support this assumption, but if the shift did not begin there it must have started shortly after the Navajos' return to their homeland. By the late 1870s or early 1880s, blanket-dresses were reserved by most Navajo women for special occasions.

The Navajos were finally allowed to leave Bosque Redondo in June of 1868. About seven thousand men, women, and children made the long trek back to a reservation that encompassed but a fraction of what they considered their traditional homelands in northeastern Arizona and northwestern New

Mexico. Here they commenced the reconstruction of their former way of life, with the proviso that they would never again harrass their Spanish, Pueblo, or Anglo-American neighbors. They were to receive annuity goods for the next ten years in the form of agricultural implements, seed, blankets and cloth, clothing, food, and other items designed to help them reestablish themselves as a self-supporting people. Though it had failed to make farmers of the Navajos at Bosque Redondo, the United States government was still committed to converting them to a settled way of life. Administrative authority over the tribe had been shifted from the army to the Bureau of Indian Affairs in 1867, and the following year an agent was established at Fort Defiance. He was charged with overseeing the distribution of annuity goods and otherwise meeting the Navajos' needs, and with regulating their affairs vis-à-vis one another, neighboring Indians, farmers and ranchers, and the federal government.

The ensuing three decades were a period of change for the Navajos. Charles Amsden called these years the Transition period, referring specifically to the transition from blanket to rug weaving. But the period also encompassed other cultural changes, such as the Navajos' transition from the status of government wards to a self-sufficient, independent way of life, and the change from physical isolation to increasing involvement with an encroaching white civilization and its market economy.

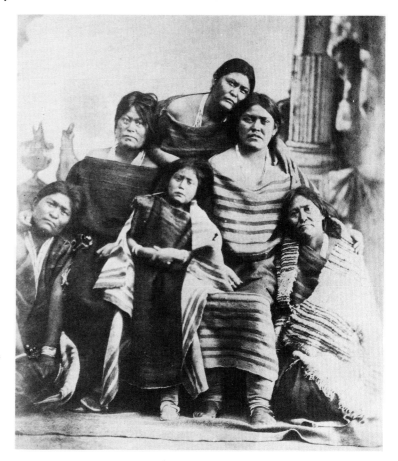

Figure 6. Navajo women and a girl wearing traditional two-piece blanket-dresses and striped serapes. Fort Sumner (Bosque Redondo), New Mexico, 1864–1868. (Courtesy Museum of New Mexico, photo no. 38207.)

Upon their return home, the Navajos were impoverished. Their first concern was to rebuild their sheep herds. A pitifully small start in this was made in 1869 with a government issue of fourteen thousand sheep—less than two per capita. Undaunted, the Navajos struggled over the ensuing years to increase their stock holdings, often trading annuity goods for horses and sheep, which to them were far more desirable (fig. 7). By 1892 they were reported to own 1.75 million sheep. The importance of the horse in Navajo culture in those transition years (and subsequently) is reflected in weavings, which include many saddle blankets and other horse trappings.

Annuity goods issued between 1869 and 1879 included cotton string, commercial wool yarns, commercial chemical dyes (generally called "aniline dyes"), American-made wool cards, indigo dye, blankets, and various kinds of factory-woven cloth. Attempts were made to teach Navajo women how to weave on the treadle loom. W. F. M. Arny, Indian agent at the Defiance Agency, purchased "three hand looms and some spinning wheels" on a trip to New York in 1875, and hired a Miss H. W. Cook as instructor. Nothing came of this, however, and Arny's successor as agent, Alex G. Irvine, in his report to the commissioner of Indian Affairs in 1876 noted, "The hand-looms purchased and set up for them . . . have not proved to be as great a success as was hoped for. . . .The Navajos seem to prefer their own way of weaving blankets, for which they are celebrated" (McNitt 1962:154).

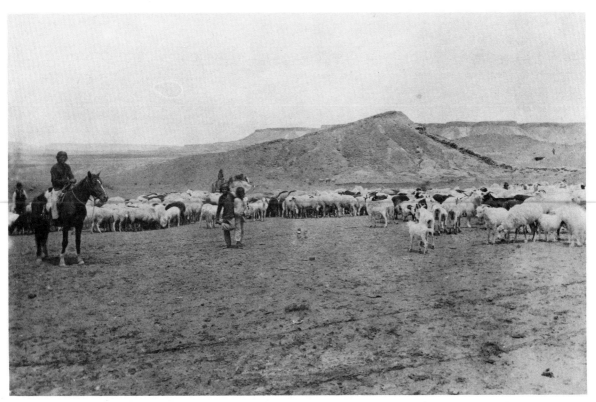

Figure 7. Navajos herding sheep and goats, 1890–1895. (Courtesy Museum of New Mexico, photo no. 16465; photo by Ben Wittick.)

Early Transition period textiles show a mix of old and new patterns and materials. The simple stripes and terraced motifs of the Classic period continue to appear, but serrate patterns increase in importance (plate 10). Women wove shoulder blankets for their own people and for the Pueblo trade, and produced horse gear such as saddle blankets and cinches in quantity.

In their study of Navajo economics, Bailey and Bailey (1982:119–33) suggested that during the transition years the Navajos changed their economic base from the pre–Bosque Redondo mix of hunting, gathering, farming, and herding to a concentration on herding with only a minimal amount of farming. They engaged in two trade networks to meet their need for items they did not produce. With Pueblos, Utes, Apaches, and Hispanics, they bartered nonproductive livestock and wearing blankets for corn, peaches, horses, buckskin, baskets, and other articles, reviving the traditional trade pattern of preinternment days. At the trading posts established on and around the reservation in the seventies and eighties, they exchanged wool, their more finely woven blankets, pelts, and goat skins for metal tools, flour, coffee, commercial cloth and clothing, yarns, and chemical dyes.

Reservation traders were the chief link between the Navajos and the alien world of the Anglo-Americans. The first traders operated at Fort Defiance in the early 1870s, and by 1889 nineteen posts licensed by the Bureau of Indian Affairs were widely scattered over the reservation, with some thirty others established just outside the reservation boundaries. The posts were run by men who for reasons of their own found satisfaction in an isolated, rugged life, far from the amenities of Victorian-era civilization. Some, like the Wetherill brothers at Kayenta and Chaco Canyon, had been born in the Southwest and had an affinity for the land and the Indian people. Others had come as traveling merchants from Germany or Czechoslovakia and expanded their markets from Albuquerque or Santa Fe to include the Navajos. A few had been stationed in New Mexico as soldiers during the Civil War and had elected to settle there.

One of the ablest and best-known of the nineteenth-century traders, Thomas V. Keam, began his career as a midshipman in the English mercantile navy. Keam left his ship in San Francisco and traveled overland to Santa Fe, where he joined the First New Mexico Volunteer Cavalry in 1865. He became Spanish interpreter to the Indian agent at Fort Defiance, and for a time in 1872 served as special agent to the Navajos. In 1875 he opened a

trading post near the First Mesa Hopi towns, and there for twenty-seven years he dealt with both Hopis and Navajos.

Juan Lorenzo Hubbell, with Keam one of the two most respected and powerful of the early traders to the Navajos, worked at Fort Wingate and Fort Defiance in the early 1870s. Born in New Mexico, he was the son of a Connecticut yankee who had served in the Mexican War and of Julianita Gutiérrez, daughter of a prominent Spanish family. Hubbell owned and operated several trading posts in the general vicinity of Ganado from the late 1870s until after 1900, supplying them from a large warehouse and store at Winslow, Arizona. His most famous post, and the one where he made his home until his death in 1930, was located at Ganado itself (fig. 8). Here he dispensed hospitality to tourists, anthropologists, Indians, Mexicans, and all who came by invitation or chance to his doors, including President Theodore Roosevelt.

Hubbell, Keam, and many other early traders learned the Navajos' language and understood their cultural values. They served the people in many capacities—as friends, doctors, bankers, judges in disputes, and spokesmen before Anglo officials and courts.

The Atlantic and Pacific Railroad, which reached Gallup in 1882 on its push toward the West Coast, established a link between Navajos and the off-reservation Anglo market, with traders acting as the middlemen. It was at this

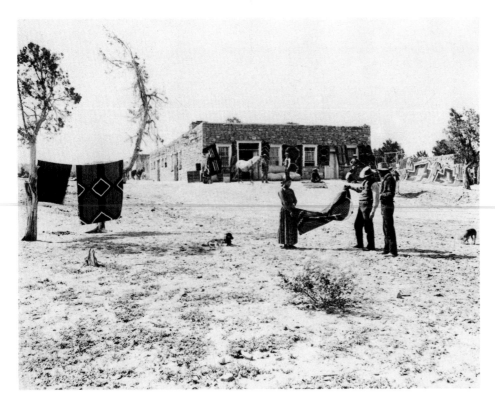

Figure 8. A Navajo woman offers a rug for trade at Hubbell's Trading Post, Ganado, Arizona, about 1885–1895. Note that she wears a skirt and blouse of commercial materials rather than the indigenous blanket-dress. (Courtesy School of American Research Collections in the Museum of New Mexico, photo no. 16479.)

time that traders began to influence the character of Navajo textiles by conveying to the weavers with whom they dealt Anglo preferences in color, design, size, and quality of blankets. They did this simply by placing a higher value in trade goods on pieces that they knew could be sold for a cash profit on the wider market.

Probably about two-thirds of the blankets woven between 1870 and 1890 were ordinary coarse wearing blankets that entered the traditional trade network; the remainder, presumably of better quality, went to trading posts and thence to tourists and to retail outlets in the eastern United States. Wool was in great demand after the Civil War, and Navajos prospered through its sale. It was more profitable for many of them to trade their wool for commercial weaving yarns than to spend their time and energy in cleaning, spinning, and dyeing it themselves. This was the heyday of the "Germantown" blanket woven of commercial yarns in bright synthetic colors.

By the late 1880s, the Navajos were better off than during any previous period in their history. In 1892 they were reported to be the wealthiest tribe in the United States with the exception of the Osages, who at that time were said to enjoy the highest per capita income of any group in the world (Bailey and Bailey 1982:120). But Navajo economic well-being ended in the early 1890s through a combination of events that undermined the wool trade. Sheep herds built up since 1870 grew so large that range lands were sadly overgrazed. A drought in 1891–92 compounded the problem, and many animals starved. With the financial panic of 1893 in the eastern United States, the price of wool dropped disastrously low, and by 1894 the Navajos were in economic trouble. It was at this point that several traders, already aware of the potential value of Navajo textiles in the expanding tourist market, urged weavers to produce rugs rather than blankets. By discouraging the use of commercial cotton string for warp and Germantown yarn for weft, and by instead persuading the weavers to utilize wool from their own sheep, they helped to restore at least some monetary return to Navajo sheep owners.

The internal demand for native-woven textiles other than belts and saddle blankets had by that time virtually ceased, as both men and women were wearing European-style clothing made of commercial materials acquired at the trading posts (see fig. 8). Soft, brightly colored, Pendleton wool blankets from American mills in Oregon had largely replaced handwoven mantas and blankets within the Navajos' own society as well as among their traditional Indian customers. Indeed, had the efforts of Anglo traders and

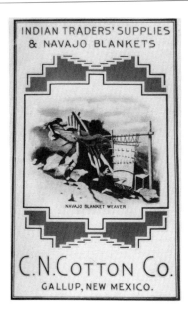

INDIAN TRADERS' SUPPLIES
& NAVAJO BLANKETS

NAVAJO BLANKET WEAVER

C.N.COTTON CO.
GALLUP, NEW MEXICO.

Figure 9. The cover of a catalogue published by the trader C. N. Cotton in 1896.

dealers to develop the market for rugs failed at this time, weaving probably would have ceased to exist as a viable craft among the Navajos.

Fortunately, in the eastern United States at the turn of the century, interest was growing in the American West and its Indian populations. Dealers were able to capitalize on this flourishing market by supplying rugs that were compatible with Anglo-American tastes and with the decor of eastern homes. Between 1896 and 1911, several traders issued catalogues and circulars advertising the work of their weavers (fig. 9). The Harvey hotels, a chain of hostelries located along rail routes in New Mexico and Arizona, featured shops selling Indian handicrafts to travelers (fig. 10). Weavers demonstrated their work in these shops and in the Hopi House, the hotel built by Fred Harvey at the Grand Canyon in 1905. Thousands of rugs purchased for Harvey from reservation traders moved through his shops to museums and collectors all over the country.

From his trading post in Chaco Canyon, Richard Wetherill also publicized rugs and sold them to several outlets in Texas at the turn of the century (McNitt 1957:182–83). He had worked with the Hyde Exploring Expedition, an organization started in 1893 by two wealthy New York brothers, which opened retail outlets in Boston, New York City, and

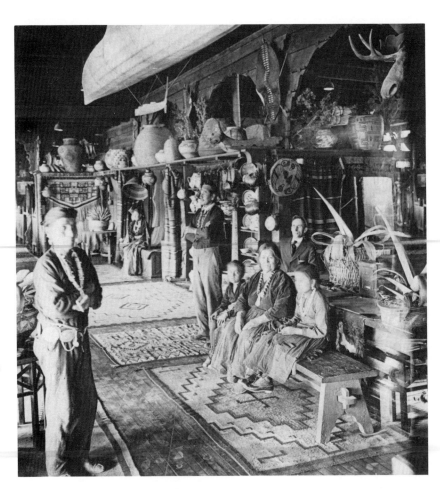

Figure 10. The Indian Room in Fred Harvey's Alvarado Hotel, Albuquerque, New Mexico, in the early 1900s. Again notice the American-style clothing. (Courtesy Museum of New Mexico, photo no. 89390; photo by Keystone View Company.)

18 · NAVAJO WEAVING

Philadelphia. Although the Hyde organization did not survive beyond 1910, according to Amsden (1949:194) "it did much ardent propaganda in the East at a time when the market for Navajo rugs was still in the making."

Throughout the first phase of the Rug period, from 1895 until 1940, trading posts whose owners were interested in the weaver's art became style centers. That is, weavers living around a given post developed, at least partly in answer to the trader's taste, a style or a particular pattern that came to be associated with the post and was sometimes named for it (fig. 11).

While these regional styles are well known to Navajo rug fanciers, it is important to note that most rugs have not conformed to any of them, but are what Gilbert Maxwell, writing in 1963, called "general rugs." Maxwell estimated that seventy-five percent of the rugs woven in any given year would fall into this stylistically nonaligned category. Nowadays, rugs exhibiting a particular regional style may in fact have been woven anyplace on the reservation. The styles have become types and need not be confined to weavers living in the region where they originated.

The Navajo economy has never completely recovered from the blow it suffered with the collapse of the wool market in the 1890s. An expanding

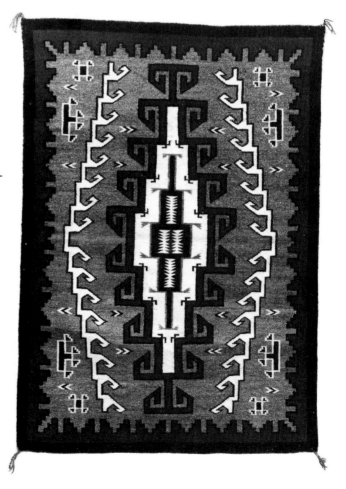

Figure 11. A recent example of a regional style that originated in the Ganado area in the early twentieth century. This Ganado-Klagetoh rug is distinguished by strong central design motifs, complex bordering, and a combination of grey, black, white, and red yarns. About 1950, 64" x 45" (SAR T.478).

population, coupled with the continuing depletion of rangelands through drought, erosion, and overgrazing, created a desperate situation that led in the twentieth century to increasing dependence on welfare programs administered by the United States and tribal governments. Strenuous efforts were made between 1920 and 1940 to improve the quality of Navajo weaving and silverwork and to expand the market for these crafts as a means of alleviating Navajo poverty and economic dependence. The United States Department of the Interior established the Indian Arts and Crafts Board in the early 1930s to help improve the status of crafts, and the departments of Interior and Agriculture jointly established the Southwestern Range and Sheep Breeding Laboratory at Fort Wingate in 1935. The laboratory experimented with breeding sheep that would provide a good, spinnable wool for Navajo weavers. At the same time, a group of Anglo-Americans interested in improving the design and quality of Navajo rugs greatly influenced the character of weaving by sparking a movement among some Navajo women to develop natural vegetal dyes as a substitute for the inferior commercial ones they were using. The general quality of Navajo weaving did improve through governmental and private efforts, but the economic impact of this upgrading on the tribe as a whole was minimal. In 1940, for instance, the sale of crafts, including jewelry, accounted for only nine percent of Navajo tribal income.

The situation was temporarily relieved during World War II as men and women employed in off-reservation factories and military services sent cash back to their families. In 1973, however, unemployment among Navajo adults on the reservation was over sixty percent. A study of the economics of weaving conducted that year by the Navajo Community College (Roessel 1983) showed that a woman received only about thirty cents an hour for making an above-average-quality rug; even so, she could contribute significantly to the well-being of her family. As Roessel (1983:595) pointed out, "With many of the limited jobs being seasonal and uncertain . . . the role of the women in weaving to provide a reliable source of food and clothing is of extreme importance." Indeed, a weaver may bring in the only cash her family receives in the course of a year. In view of the fact that some twenty-eight thousand women knew how to weave in 1973 and that weaving is taught in most reservation schools and at the community college, "there should be little possibility that Navajo weaving will become extinct, at least so long as the unemployment rate is high and average family income remains so low" (Roessel 1983:596).

To remain a source of income for its practitioners, Navajo weaving must continue to have a market in white society. In the contemporary marketplace, there are a number of "name weavers" whose work is of exceptional quality and is in demand by discriminating collectors. The cash return for these craftswomen is substantially more than thirty cents an hour.

We probably err in considering the fate of Navajo weaving only in economic terms. Undoubtedly many weavers work because they get pleasure from doing so, and because weaving is a part of their heritage that they would like to help perpetuate. As Reichard put it in 1936 (p. 187):

> Handcraftmanship must be reckoned not only in dollars and cents but also in satisfaction. There is something about making a beautiful object which cannot be measured tangibly. There is no doubt that the weavers feel this. I sincerely believe that Atlnaba and Maria Antonia would weave if they never received a cent for their blankets. Their artisanship is to them a pride and a joy. They try to get as much money as they can for it, but that is a matter distinct from their aesthetic reward.

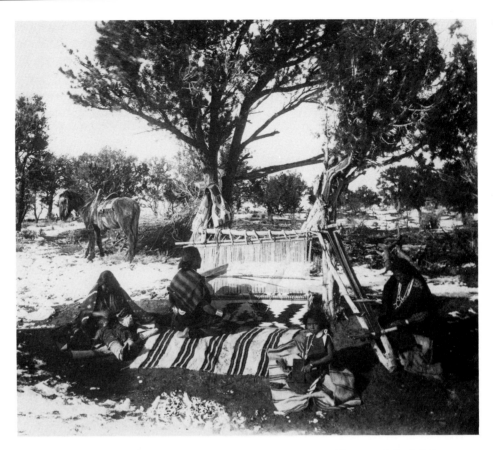

Figure 12. Carding, spinning, and weaving on the wide vertical loom and the belt loom. Charlie the weaver and family, near Keam's Canyon, 1893. (Courtesy National Anthropological Archives, Smithsonian Institution, photo no. 2433; photo by James Mooney.)

Mastering a Borrowed Art: The Techniques and Materials of Navajo Weaving

Judging from the archaeological remains of Navajo textiles dated between 1750 and 1850, and from eighteenth-century Spanish accounts of Navajo weaving, it is apparent that the Navajos adopted from their Pueblo neighbors not only the belt loom and the wide vertical loom (fig. 12), but also weave techniques, materials (fibers and dyes), and types of woven clothing. Their wide-loom products, however, do reflect certain weaving practices that apparently originated with them, and these allow us to distinguish Navajo textiles, even very early fragments, from those of the Pueblos.

Articles woven on the vertical loom include shirts, breechcloths, mantas, blankets, and, since the turn of the century, rugs. The backstrap or belt loom is used in making narrow, warp-faced hair ties and garters as well as wider belts with warp-float center panels. Belts and bands are visually and technically indistinguishable from their Pueblo prototypes, since the Navajos did not employ novel techniques in working on the narrow loom.

Modern Navajo weavers have incorporated techniques borrowed from Pueblo, Hispanic, and Anglo handweavers into their rugs; and they use both traditional native materials and commercial dyes and yarns.

TOOLS AND TECHNIQUES

While Navajo weavers have continued to use the basic looms and accessories introduced to them centuries ago by the Pueblos, their innovative approach to the wide loom has resulted in distinctive textiles that reflect a freer, more adaptable attitude toward their art than that of their teachers. Some of the

Navajos' technical refinements may be said to have fostered improvements in the quality of or changed the appearance of traditional textile forms: for example, the tight weft-faced weave that resulted in waterproof blankets and the plain-weave tapestry process that permitted weavers to create a wide variety of patterns and, later, pictures. Other innovations, such as methods for keeping the working area of a piece within easy reach, were purely practical in nature.

Weaving on the Vertical Loom. The processes of warping the upright loom and the mechanics of its operation have been described in detail in several publications (Amsden 1949:37–45; Pendleton 1974; Reichard 1936:63–85), and the descriptions will not be repeated here. Figure 13 diagrams the method of laying warp for the wide loom, and figure 14 shows the warps on the loom and all tools and loom parts. For both Navajos and Pueblos, the warp is a continuous length of yarn fastened between a lower (cloth) beam and an upper (yarn) beam. The weaver sits in front of the loom and inserts wefts from the cloth beam up.

Warp yarns are divided into sets, two in number for simple plain weave. One set of warps (composed, let us say, of warps two, four, six, and so on) is fastened by string loops to a slender stick, forming the heddle. When this device is pulled toward the weaver, it separates the even- from the odd-numbered warps, creating a triangular space, the shed, between them. The weaver holds the shed open by inserting the batten, or weaving sword, and turning it on its side while weaving in a line or pick of weft yarn, which will

Figure 13. Warping for the vertical loom. *a*, Warp yarn is wound figure-eight fashion over and under sticks 3 and 4 and around poles 1 and 2, which are fastened to stakes in the ground. *b*, Sticks 3 and 4 are pushed together so that 3 forces up all odd-numbered warps, and 4, all even-numbered warps. *c*, Odd-numbered warps are fastened by string loops to an additional stick, 5, forming the heddle. Stick 3 is removed. Stick 4 will serve as the shed rod. *d*, Selvage cords are twisted between warp loops outside of poles 1 and 2. *e*, The yarn beam and the cloth beam, 6, are next lashed to the selvage cords. Poles 1 and 2 are removed, and the warp, secured to yarn and cloth beams, is fastened between the lower bar and the tension bar of the loom.

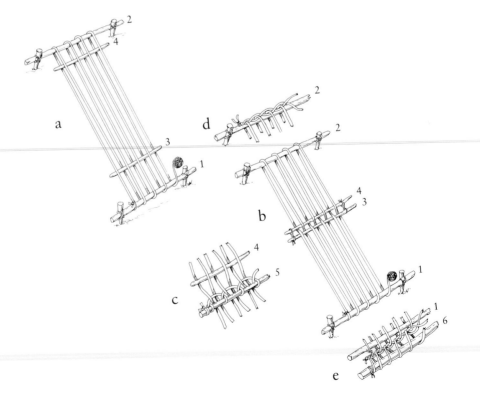

lie in front of the odd-numbered warps. After the pick has been beaten into position with a weaving fork, the shed rod, which was inserted behind the odd-numbered warps before weaving commenced, is brought down to the heddle loops, forcing those warps forward to form the second shed. The batten is inserted in the new shed to hold it open while the second pick of weft is drawn in, this one passing in front of all even-numbered warps. For a plain weave, this alternation between the two sets of warps continues until an entire piece is completed. Twill weaves may require two, three, or more heddles, plus the shed rod, depending on the number of warp sets.

Both warp and weft selvages aid the weaver in spacing the picks of yarn evenly. Heavy plied yarns twisted between the loops formed at each end of the warp set as it is being prepared, before it is fastened to the loom bars, will appear as warp selvage cords on the finished piece. Yarns intended for weft selvage cords are hung loosely at the right and left edges of the warp set after it has been fastened in an upright position on the loom, and these will be twisted between the weft loops formed during weaving. Navajos customarily use two three-ply yarns and Pueblos three two-ply yarns in their selvages, a difference that helps to identify the tribal origin of a textile. However, both groups sometimes employ two two-ply yarns.

After a manta or blanket was removed from the loom, the Pueblo weaver normally left weft and warp selvage ends at the four corners tied separately, or knotted or braided them together starting well beyond the corners of the fabric. Navajo women, on the other hand, usually fastened

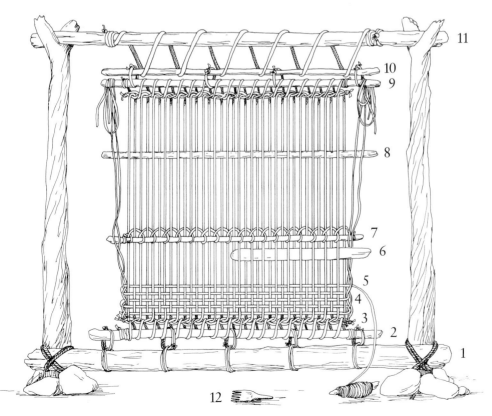

Figure 14. The vertical loom and weaving tools. *1,* Lower loom beam. *2,* Cloth beam. *3,* Warp selvage cords. *4,* Weft selvage cords. *5,* Weft yarn in plain weave. *6,* Batten. *7,* Heddle. *8,* Shed rod. *9,* Yarn beam. *10,* Tension bar. *11,* Upper loom beam. *12,* Weaving fork.

selvage ends together at each corner and ran extra lengths of yarn through the fabric to make small tassels (fig. 15).

Navajo weavers also found a way of handling the weft that seemed more convenient to them than the standard Pueblo practices. The Pueblo craftsman winds his weft yarn on a long, slender stick and carries each pick of weft from side to side of the web. Just below the working edge of his weaving, he fastens a long stick called a "temple," pinning its ends to the edges of the fabric. By moving the temple up as he weaves, he can keep his fabric even in width. The Navajo loom, however, is not equipped with a temple, nor would one be functional in view of the way a Navajo woman handles her weft. With the weft yarns wound on short sticks, she fills in one section of warps at a time, no wider than the length of her batten, allowing a slanting line to develop along its edge. The adjoining section is then filled in, the wefts of the two meeting along the line but not interlocking. This break in the fabric is called a "lazy line" (fig. 16). It is found on most Navajo wide-loom fabrics, but although it appears on some Zuni blankets, it is not characteristic of Pueblo weavings in general. Since the Navajo weaver builds her fabric up to uneven heights as she works, there is no fixed horizontal working edge behind which a temple could be fastened. In order to keep the edges of the web from drawing in as she weaves, a Navajo woman nowadays will sometimes tie the outermost warps to the side supports of her loom.

The number of wefts to the inch is markedly greater in most Navajo blankets of the Classic and early Transition periods than in Pueblo blankets of the same age. Average yarn counts are 20 to 100 wefts and 6 to 12 warps to the inch for Navajo plain-weave blankets, as compared to 10 to 20 wefts and 3 to 5 warps for Pueblo blankets (Wheat 1979:31). This tightness of weave accounts for the valued waterproof quality of Navajo Classic period blankets.

It may be that working with a limited length of weft yarn at a time allows the weaver to force wefts more closely together than is possible when battening a weft the full width of the web. In any event, Navajo blankets and

rugs are weft predominant to weft faced, the latter meaning that wefts are so closely battened that warps do not show at all in the finished piece.

Both the manner in which wefts were inserted and the closeness with which they were beaten down are associated with differences in design development between Pueblo and Navajo textiles of the 1800s. The Pueblo preference for carrying a weft yarn the full width of the fabric, or web, seems a logical correlate of weaving simple weft stripes, a method of patterning that has been particularly characteristic of Pueblo blankets and rugs. The Navajo practices of building up a fabric in sections and battening wefts closely together are particularly compatible with the development of tapestry weave, the weavers' predominant technique for producing designs from the late 1700s to the present. Although the prehistoric Pueblos' preferred method of patterning a wide-loom fabric was twill-weave tapestry, curiously enough they rarely used plain-weave tapestry. Neither tapestry technique has been employed in traditional Pueblo textiles in historic times, although Pueblo weavers did produce some tapestry-patterned rugs around the turn of the century.

Tapestry is defined as a weft-faced weave in which the wefts are discontinuous (Emery 1966:78). A pattern is built up of small design elements in different colors of weft, each color filling in a limited warp area. In Navajo tapestries, two different colors of weft yarn usually interlock between warps where they meet at the edges of design elements (see fig. 16), although they sometimes dovetail around a common warp if the line of join slants steeply. The weaver uses the warps much as a painter does a canvas: simply as the foundation on which to construct a pattern in variously colored wefts. Each color of yarn is wound on a small stick, and when not in use during the weaving process it hangs in front of the finished portion of the web.

There is a technical relationship between tapestry weave and lazy lines, in that both depend on the use of discontinuous wefts. In tapestry, however, the breaks correlate with the length of a weft pick of one color (that is, with the width of a design element), whereas the motivation in weaving a lazy line is apparently just to keep the weaving area conveniently limited in extent. Lazy lines occur within a color zone, not between two zones of different colors, and adjoining wefts are neither interlocked nor dovetailed in this technique as they are in tapestry.

Plain-weave tapestry, in itself a very simple process, can be used to produce extremely complex patterns made up of an unlimited number of colors. It became the decorative technique par excellence among the Navajos,

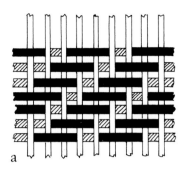

Figure 17. Two common types of Navajo twill weave. *a*, Over-two under-two balanced twill. *b*, Four-thread diamond twill. One diamond pattern is emphasized by darker shading.

permitting weavers to reproduce on their looms designs drawn from many different sources. Classic and Transition period Navajo dresses and some mantas had tapestry-woven borders in place of the embroidered or twill-weave borders found on Pueblo mantas. The terraced designs decorating the Navajo garments were drawn from traditional Navajo coiled basketry (see fig. 2). As the world around them changed in the years following their internment at Bosque Redondo, the Navajos even wove into their textiles pictures of objects that intrigued them, such as railroad trains and cars.

In addition to plain weave, the Navajos learned twill weaving from the Pueblos, as it was the traditional technique for shirts and for black or white mantas with indigo blue diamond-twill borders. They did not, however, undertake to weave men's striped shoulder blankets ("chief blankets") or serapes in twill rhythm. In fact, twilling does not appear as an important technique among them until the early Transition period, when they used it extensively in weaving saddle blankets and cinch straps. The wefts in a twill-woven fabric can be battened more tightly than those in plain weave, so that the piece feels almost twice as thick as a plain-weave fabric of the same type of yarn. Sturdy twilled fabrics are therefore well suited for hard usage as horse trappings. Twilling continues to be used in modern times to create geometric self-patterns on Navajo rugs (see fig. 73).

Twill weaves are produced on three, four, or more warp sets. In most Navajo twills there are four sets, three controlled by string loop heddles and the fourth by the shed rod. Each weft passes ("floats") over two warps and under two warps, and each successive passage of weft is stepped one warp to the right or left of the previous weft. This creates diagonal lines of floats on the surface of the fabric. Heddles may be strung in such a way as to create diamond patterns as well as simple diagonal lines (fig. 17).

In Pueblo twills, wefts are continuous, with each pick passing from edge to edge of the web; but Navajo women sometimes applied their practice of weaving a fabric in sections to their twills, producing twill-weave tapestry. In so doing, however, they tended to disturb the regular float rhythm of a weft pick. As in plain weaves, the presence of lazy lines in a twill textile marks the piece as being of Navajo manufacture. Contemporary Navajo twill-woven rugs are not tapestries and do not have lazy lines; each weft passes from edge to edge of the fabric.

In making traditional twill-weave mantas, Pueblo weavers finished one border, turned the entire warp set upside down so that what was originally

the cloth beam became the yarn beam, and then wove the second border and the body of the manta. This practice, sometimes employed by the Navajos as well, helped keep the working edge at a convenient height. It was also a time-saving device: since many mantas' borders require a different heddle rig from their centers, weaving both borders first meant that the heddles did not have to be restrung more than once. Where the first woven border and center section of weaving met, unused lengths of selvage yarn were left at the sides of the manta. These were usually plaited into short braids by the Pueblos, but the Navajos often worked them tightly back into the web instead.

Since Navajo Classic period serapes and most mantas were fashioned in plain weave throughout, there was no need to restring heddles for the center section. Thus the principal reason for reversing the warp set on the loom did not obtain. The secondary reason for doing so—to keep the working edge within easy reach—still existed, however, which may explain why some plain-weave mantas and serapes were indeed reversed. Navajo women also devised a method apparently not used by the Pueblos to accomplish this end. They simply lowered the yarn beam and folded the completed portion of the web in back of the loom, lashing the warps along the weaving edge tightly to the cloth beam. Weaving was then resumed. This practice left a line of puckers in the completed piece where the edge of the web had been attached to the loom (Reichard 1936:81).

In the early 1900s, when traders urged the weaving of exceptionally large rugs, some women originated other techniques still used today for keeping the area on which they were working within convenient reach. They rolled the extra-long warps carefully around the yarn beam, releasing them only after a woven portion of the rug had been folded behind the loom and lashed down to the cloth beam. Or they might fold their extra-long warps over the upper loom bar, bring the yarn beam down in front of or behind the loom, and fasten its ends to the side supports. Other weavers had outsize loom frames constructed to accommodate the desired rug proportions (Reichard 1936:65–67).

It should be apparent from the foregoing discussion that while Navajo women learned from the Pueblos how to construct and manipulate the wide vertical loom and how to weave certain traditional articles of clothing in plain and twill techniques, they were not inhibited by the strict conventions that controlled historic Pueblo weaving (at least as we know it for the Hopis).

Tradition prevented change in articles of clothing made by the Pueblos, determining how they should be woven and decorated and when they should be worn. Such strictures were not a part of Navajo culture, however, and by 1800 or shortly before, Navajo weavers had begun to devise their own distinctive ways of handling warp and weft. Their development of plain-weave tapestry, a non-Pueblo technique, permitted them great freedom in design elaboration over the ensuing years, and the flexibility of their approach to their art continues to be apparent in modern textiles.

The Belt Loom. The Navajos displayed no such originality in handling the belt or backstrap loom. Little notice has been taken of their narrow-band weaving, and few actual examples survive from the Classic period, though woven belts, hair ties, and garters are mentioned and sometimes illustrated in accounts of early Navajo dress. It is clear from what evidence we do have that identical tools and techniques were used by the Navajos and Pueblos in weaving these articles.

The loom used for narrow-band weaving, as recorded by Matthews (1884:389–91), Reichard (1936:133–40, 205), and Shufeldt (1891), consists of two end sticks around which warps are wound in roller-towel fashion (fig. 18). One of these sticks is fastened to the upper bar of the upright loom, the other to the lower bar. Or they might be secured to two other stationary supports, or the upper stick to a stationary support and the lower one to a strap passing around the weaver's hips. Weaving then takes place on the upper plane of warps, the whole warp set being pulled over the two sticks when necessary to keep the work area within easy reach.

When the belt or tie is considered to be long enough, the unfilled section of warps is cut at midpoint, and the loose ends are twisted into fringes at both ends of the band. A Navajo woman traditionally wore the long warp-patterned belt wrapped once or twice around her waist, securing it by tucking in the fringes (Reichard 1936:140).

Both Navajo and Pueblo weavers employed warp-faced plain weave in articles made on the belt loom, creating warp-float patterns in the center panels of the wider bands (belts and garters). A warp-faced weave is one in which the warps in a unit of measurement markedly outnumber the wefts and are so closely packed that wefts do not show on the finished piece, but simply act as fill.

The two warp sets needed for warp-faced plain weave are controlled by

a string loop heddle and a shed rod. Warps that are to form a design by being floated in the center panel are picked with the fingers and a small stick and held up while weft is passed behind them. The weft yarn is wound on a stick for easy passage through the warps, and a small batten is used to force wefts down after they are inserted. There is no record of the Navajos using supplementary heddles to control pattern warps, as was described for the Hopis in 1940 (MacLeish 1940:304–10; see also Kent 1983c:fig. 74); nor did they adopt the European hole-and-slot heddle, used at one time by the Pueblo Indians.

The technique used by Navajos and Pueblos for the center design panels of belts and garters is an alternating float weave with predominant warps (Emery 1966:114–20, figs. 192, 195, 210, 211). In this weave, every other warp passes over one weft, under one weft, in a regular plain-weave rhythm. Warps of the alternate set may float over three wefts, under one weft. Yarns are selected from this set and floated so as to form geometrical figures on a plain-weave ground (fig. 19). This is the simplest possible variation of plain over-one under-one weave and is widespread as a belt technique in North and South America.

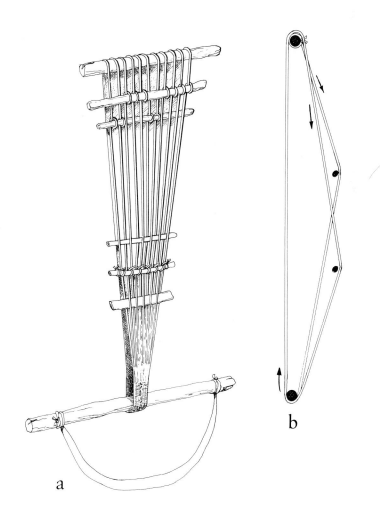

Figure 18. a, Arrangement of warp and loom parts for the backstrap loom. *b*, Method of stringing warps for the backstrap loom. The heddle and shed rod control only those warps on the forward plane.

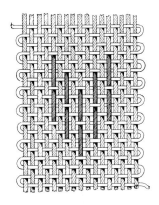

Figure 19. Diagram of a warp-float pattern in which red warps float over three wefts and under one, while white warps maintain a regular over-one under-one rhythm. The red floats are emphasized by darker shading.

For some reason that I do not understand, four-ply commercial red and green wool yarns and commercial white cotton string were accepted as the appropriate materials for warp-faced belts and ties early in the Transition period, a tradition that has been maintained to the present day. In contemporary traditional Navajo belts (and in Pueblo-woven Navajo-style belts), wefts are of white string. In the center design panel, warps in the plain-weave set are white, while floated warps are red and may be paired (fig. 20). Found archaeologically in the Southwest, the warp-float process was undoubtedly taught to the Navajos early in their weaving career by the Pueblos. Apparently the technique and certain basic motifs used in Navajo and Pueblo belts have not changed from early historic times to the present. The only real difference between Classic period examples and contemporary ones is in the yarns and dyes used, which vary in accordance with availability.

MATERIALS

Like looms and weave techniques, yarns and dyes were borrowed from the Pueblos in the early days of Navajo weaving. Since about 1800, however, Navajo weavers have shown their eclecticism in the ways in which they have experimented with any new materials that became available through trade, their own trial and error, or purchase. Until the late Classic period, they used primarily native materials—wool from their own flocks and a yellow vegetal dye—enriched by the acquisition of Mexican indigo and, beginning in the late 1700s, by red yarns raveled from trade cloth. In the mid-1800s, brightly colored commercial yarns, notably Saxony and Germantown, came into wide use, greatly changing the appearance of Navajo textiles; and by the early 1880s, chemical dyes began to replace vegetal indigo and yellow as well as raveled reds. Navajo weavers returned almost exclusively to the use of native wool in the 1890s in response to the demands of traders and Anglo collectors, who sought "authentic" indigenous products. Today yarns may be either commercial or handspun and dyes chemical or vegetal, depending on a weaver's preference.

Yarns. The traditional material used in Navajo textiles has always been single-ply handspun wool yarn prepared by the weaver from the fleece of her own sheep. The sheep introduced into the Rio Grande Valley by the Spaniards in

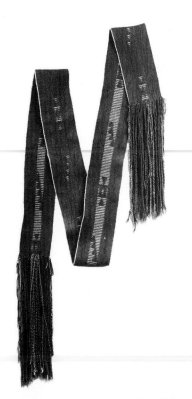

Figure 20. A handsome contemporary belt. Following established tradition, there are paired red warps in the center design panel and two motifs alternating the length of the piece, separated by a ladderlike pattern. 118" (including fringe) x 4½" (SAR 1979-6-74).

the 1500s were descended from the churro, the ordinary sheep of the peasants of southern Spain. Churro wool fibers are long, straight, glossy, and low in lanolin content, making them easy to clean and spin by the simple hand methods of the Navajos. Their lack of oil allows for the ready absorption of indigo and native vegetal dyes.

The Navajos cleaned their wool before spinning it into yarn, sometimes by washing it in yucca-root suds (Amsden 1949:33–35) but more often by simply shaking out the sand and picking out burrs and twigs. Reichard's weavers (1936:14) insisted that washing the wool matted it, making it lumpy and difficult to card, and that only in the rare cases when wool was too dirty to dye was it washed. "More commonly it was laid on a rock in the sun and vigorously beaten" (Reichard 1936:14).

Following cleaning, the process of carding effectively rid the greaseless churro wool of any remaining sand or other foreign materials. Carding is the combing of raw wool between two small, toothed, rectangular boards so that the fibers lie parallel to one another (see fig. 12). Cards from the Old World with teeth made of teasels (thistles) were probably introduced by the Spaniards and may have been copied by the Navajos, using local plants (Amsden 1949:35, 36, and plate 10d). Late in the Classic period, American-made cards with fiber bristles apparently became available to Navajos and Pueblos alike. Jacob Hamblin and a party of Mormons sent to the Hopi country by Brigham Young in 1858 returned the following year bringing trade goods that included "wool cards, spades and shovels" (McNitt 1962:90). It is likely that American-made commercial cards had been imported into the Southwest over the Santa Fe Trail even before that time. Modern wool cards with steel teeth are used by present-day Navajo weavers (fig. 21).

Figure 21. A pair of wool cards (SAR M.519), a spindle (SAR M.348), and a weaving fork (SAR M.398). At lower right is a skein of warp yarns so tightly twisted that they double on themselves when not under tension on the loom (SAR 1982-2-1). At left center is a ball of soft weft yarn (SAR M.521). (Photo by Deborah Flynn.)

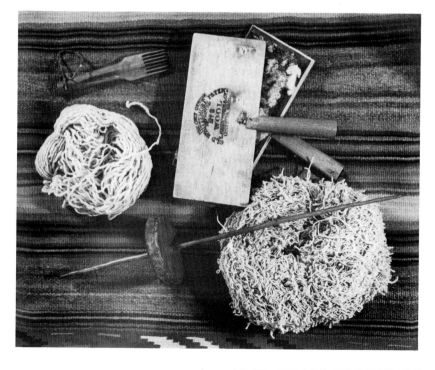

After carding, fibers must be spun, or twisted together into yarn. This was accomplished with the indigenous stick-and-whorl spindle (or *malacate*) borrowed from the Pueblos in the 1600s. The Navajo works the spindle by resting the tip of the short end on the ground to her right and twirling the shaft with the fingers of her right hand (fig. 22). With the left hand, fibers are drawn from the pad of wool that results from the carding process, fastened to the tip of the long end of the spindle shaft, and twisted together as the shaft revolves. This manner of operation parallels that employed by the Rio Grande Pueblo Indians and is quite unlike the way in which the tool is used by the Hopis—an indication that the textile arts were acquired by the Navajos in New Mexico. (Zunis, in the early 1900s, used both the Rio Grande Pueblo and the Hopi techniques of spinning.)

Handspun yarn is typically single ply and z-spun, meaning that the individual fibers are aligned in the direction of the center bar of the letter *z*

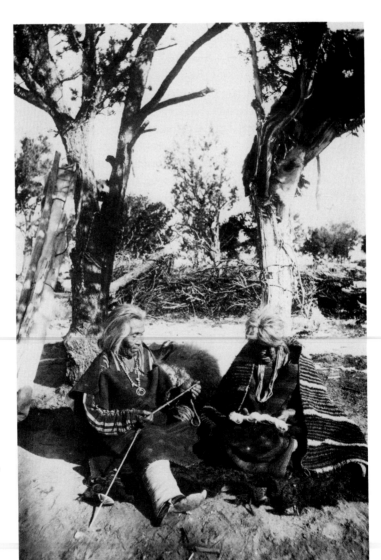

Figure 22. Preparing wool yarn at Charlie the weaver's camp near Keam's Canyon, 1893. (Courtesy National Anthropological Archives, Smithsonian Institution, photo no. 2429; photo by James Mooney.)

(/) when the yarn is held at a right angle to the ground (fig. 23). Yarn produced by a single spinning will generally be too soft and thick to be a serviceable weaving material. For weftage, yarn will usually be retwisted once. Warp yarns, which are much harder than wefts, must be retwisted three or more times to make them tight enough to withstand the tension and friction to which they will be subjected during weaving (see fig. 21). According to Reichard (1936:16, 21), weavers of the early 1930s made warp yarn by carding mohair, or goat wool, into sheep wool. Since mohair fibers are long, straight, and wiry, they supply additional strength. I suspect that this custom was observed in the Classic period, as Classic warps are hard and strong. Two or three single-ply yarns are twisted together for selvage cords. This is done with an S-twist; that is, the yarns are twisted together so that they are aligned in the direction of the center bar of the letter *s* when the yarn is held upright at a right angle to the ground.

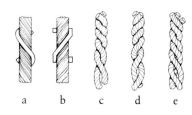

Figure 23. Types of yarn. *a,* Single-ply s-spun. *b,* Single-ply z-spun. *c,* Two-ply, z-spun, S-twist. *d,* Two-ply, s-spun, Z-twist. *e,* Three-ply, z-spun, S-twist.

Beginning probably in the mid-1700s, the Navajos supplemented their indigenous, handspun yarns with commercial products. The first such fibers were obtained by raveling manufactured trade cloth of several different types that originated in various parts of the world. The object of this process was not to avoid the labor of preparing raw wool but to acquire colors, primarily red, not otherwise available. These early raveled yarns were fine—about thirty-five millimeters in diameter—and were generally used in pairs or triples, the strands being laid parallel to each other but not twisted together. These yarns are called "bayeta" (also spelled "bayetta") in the literature on Navajo weaving. The term is often applied to synthetically colored cloth, but in this book it will be reserved for natural-dyed wools.

S-spun worsteds are the most common raveled yarns in Navajo textiles woven before 1860. These are hard, napless yarns spun from long-staple, straight wool fibers. (The term "worsted" is also applied to closely woven, hard-surfaced cloths such as serge and gabardine.) Wheat (letter of October 2, 1981) suggests that the worsted yarns of the early Classic period may have been raveled from *alepin*, a Turkish-Syrian cloth imported into the Southwest via Mexico, or possibly from *cubica*, a comparable Spanish material. Red dye in these yarns tests positively for lac, or sometimes for lac and cochineal.

More typical of the late Classic period are z-spun raveled yarns, some of which were made from long, straight fibers, probably those of "naturally worsted" churro wool that had been woven into cloth on Spanish looms in

Mexico or the Rio Grande Valley. The reds in these yarns are usually cochineal. In other raveled yarns, s-spun as well as z-spun, found in post-1860 Navajo textiles, the individual fibers tend to be wavy or curly and short. These wool yarns have a nap, which gives them a fuzzy appearance. They were probably raveled from cloth of English or American manufacture brought to the Southwest via the Santa Fe Trail, and are usually aniline dyed.

Such raveled wools are often found in association with early commercial three-ply yarns, known as "Saxony" and "Germantown." Saxony is soft and shiny and is colored with natural dyes. It was spun from the wool of Saxony-Merino sheep in the mills of England, France, New England, and, particularly, Saxony, Germany. Early Germantown yarns generally contain chemical dyes and tend to be coarser and harsher to the touch than Saxony. The name Germantown refers to the town, now part of Philadelphia, where much of the American yarn sold to the Navajos in the 1800s was spun; the term is currently used for commercial American wool yarns in general. Three-ply Germantown yarn was first issued to the Navajos at Bosque Redondo as part of their annuity goods in 1864, and large quantities were issued to them in subsequent years. Three-ply was replaced by four-ply Germantown in about 1875.

Not all Classic period yarns fit into the above categories. A strikingly beautiful blanket (plate 2) taken from the body of the Cheyenne chief White Antelope after the Sand Creek Massacre in 1864 is woven from exceptionally fine three-ply yarns, soft and shiny like Saxony but synthetically dyed. Some of the white yarns in the piece have been identified as three-ply silk, compatible with the wool in sheen and softness. It has been suggested by the weaver Ramona Sakiestewa that the other yarns in the piece may have been spun from a combination of silk and wool like some of the fine yarns used by contemporary weavers, but this has not been tested. (It should be noted that silk has never been a significant material in Navajo weaving, although it was used experimentally in three blankets woven in 1895 [Wheat 1977:423].) The blanket appears to be unique in its yarn content, but a second, undocumented piece in the School of American Research collection (fig. 24) so closely resembles it in color choice that the two may have been woven by the same woman. The material in the second blanket is paired three-ply, synthetic-dyed yarn, somewhat coarse to the touch.

Textiles woven in the early part of the Transition period (1865–1880) contain a rather bewildering mix of yarns (fig. 25). Three-ply and four-ply Germantown were often used together. Three kinds of materials gleaned from

government-issue American cloth or blankets are also found (Wheat 1979:199–200): raveled yarns; raveled, recarded, respun yarns; and cloth strips.

Yarns raveled from aniline-dyed American flannel between 1865 and 1875 tend to be fuzzy and soft. According to Fisher and Wheat (1979:199), the "yarns are highly variable in diameter, ranging from .30 mm to 1.10 mm with most either .50 or .90 mm which reflects the wide variety of fabrics being raveled." The smallest yarns were generally used in bunches of three to five, but sometimes as many as nine served as a single weft. Intermediate-size yarns appeared as paired or single wefts, and heavier yarns, looking much like single-ply handspun, were used singly.

Some of the commercial cloth issued or traded to the Navajos between 1865 and 1880 did not yield usable yarns when pulled apart. Waste materials from this cloth—fibers, tiny bits of cloth, and threads—were sometimes carded together with native white wool fibers and then spun into regular handspun yarn that was generally pink or pale orange. Another use made in

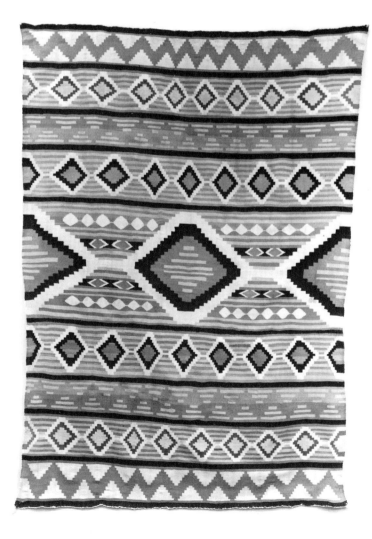

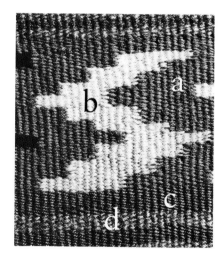

Figure 24. Woven entirely of early Germantown yarns, this late Classic blanket resembling the Chief White Antelope blanket was purchased in Santa Fe in the 1860s or 1870s. 81" x 58" (SAR T.175).

Figure 25. The mix of yarns in this child's blanket marks it as a product of the 1870s. *a,* Raveled red yarns used in sets of five. *b,* Handspun white yarn. *c,* Three-ply red Saxony yarn. *d,* Raveled red yarn fibers carded with white to make pink handspun. (SAR T.70; photo by Deborah Flynn.)

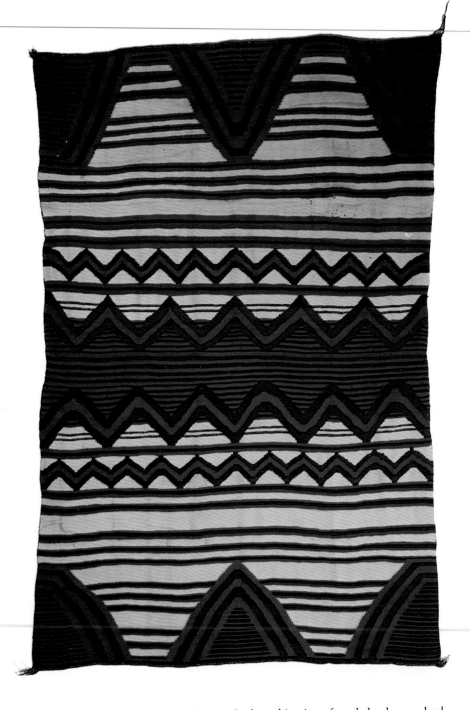

Plate 1. A Classic period serape. The standard combination of raveled red yarn, dyed with lac and cochineal, and handspun white and indigo blue is varied by the subtle use of a vegetal green dye in some of the narrow bar elements. The use of white rather than red for the background is somewhat unusual, but the terraced or stepped edges of the design motifs are typical of this period. 1850–1860, 79" x 53" (SAR T.375).

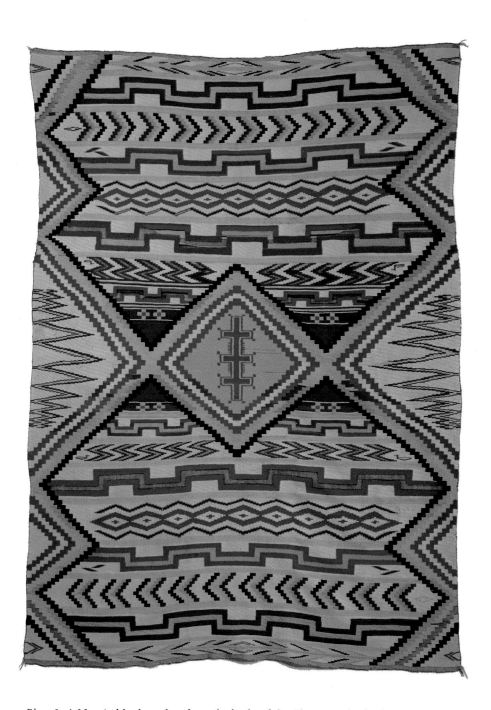

Plate 2. A Navajo blanket taken from the body of the Cheyenne chief White Antelope after the tragic Sand Creek Massacre in 1864. The complex design shows strong Saltillo influence in the large central diamond, vertical zigzag motifs suggesting side borders, and small design repeats in the horizontal design bands. Nearly all dyes are chemical and yarns commercial. 76" x 56" (SAR T.43).

the 1870s of cloth that would not ravel well was to cut it into narrow strips and weave these, either rolled or open, into a blanket as wefts (fig. 26). Information on the kinds of cloth made in American mills for the Navajo trade can be gained from studying these strips.

With the coming of the railroad in 1882 and the increasing number of trading posts established on and around the reservation in the next several years, commercial materials became readily available to Navajo women. Textiles woven between 1880 and 1900 contain aniline-dyed handspun or four-ply Germantown yarns (plates 11 and 14). Cotton string warps were frequently combined with Germantown wefts. Although string had been issued to the Navajos by the government as early as 1860, it was not used to any great extent until the 1880s. It is still to be found in pillow tops, runners, and other small tourist items, and in saddle blankets, for which, according to Fisher and Wheat (1979:199), "cotton is superior to wool because it neither shrinks nor loses its strength when wet."

Between 1868 and 1940, repeated attempts were made by well-meaning whites to "improve" Navajo sheep by introducing new breeds, such as the European merino, which yielded more meat and wool per animal than churros. The new wools, crimped and oily, proved to be difficult to clean, card, and spin by hand methods, and resistant to dyes. Moreover, by 1900 the once desirable churro wools themselves had become degraded—full of kemp or stiff fibers, coarse, and oily—partly because of interbreeding with the new breeds and partly because of poor range conditions. Most of the rugs woven between 1920 and 1950 are easily recognized by the crimped, nubby yarns they contain (fig. 27).

Apparently, the interbreeding of the churro with other sheep was resisted in some parts of the reservation. Pepper, writing of the Navajos in remote parts of Chaco Canyon in 1903, remarked that "the Navajo herdsmen are particularly careful about keeping their sheep from crossing with the

Figure 26. The corner of a cloth strip blanket collected in the early 1880s. Blue and white wefts in the blanket are handspun yarns, while red wefts are narrow strips of synthetic-dyed flannel. One strip, unrolled, may be seen in the corner tassel. (SAR T.410; photo by Deborah Flynn.)

Figure 27. Crimped yarns in a rug woven in 1950 (right, SAR T.485) contrast with smooth churro wool yarns in a Classic period blanket (left, SAR T.328). (Photo by Deborah Flynn.)

merinos of the Mexicans, as they realize that the merino wool cannot be washed or bleached and that the use of the wool in its natural state causes unsightly streaks in their blankets" (quoted in Amsden 1949:35). Reichard (1936:9) explains the reaction of Navajo weavers near Ganado to the "pollution" of churro wool:

> It would be difficult, if not impossible, for a Navajo to sum up the disadvantages of the "better" breeds, so for many years he said nothing, but quietly though firmly resisted the "improving" of his flocks. On the eastern side of the Lukachukai Mountains, however, sheep have been highly bred for weight of flesh and wool, the aim being to sell in the world market. Indeed, the policy has been so thoroughly followed in one locality that now very little, if any, Navajo wool is woven. But in the more "backward" regions of the Reservation where Navajos still live by their own efforts, the women have something to say about sheep breeding. They want wool, good wool, for weaving. They therefore select for their own work that from the "oldtime Navajo" sheep. I have seen wool of this kind so clean and long that it could be spun without carding.

Reichard (1936:16) also says that the black sheep of Navajo flocks have the crimpy wool of the merino which "takes longer to card—and the resulting laps have small crimpy tufts which no amount of carding can eliminate." This is borne out by examination of handspun yarns in modern rugs, in which black and carded grey yarns will look crimped even though white yarns, and white yarns that have been dyed, are smooth.

Since the 1950s, new kinds of yarn have been introduced to the Navajos, and this has been linked with changes in their textiles. These new yarns are spun from commercially cleaned, carded, and sometimes pre-dyed rovings, and are much smoother and more even in diameter than those from hand-carded wool. This is reflected in rugs woven from them, which tend to have a flat, smooth texture. Commercially spun and dyed single-ply yarns, also available to Navajo weavers, have the same feel, but are generally too soft and thin for practical use as material for floor rugs. Reactions among Navajo weavers to these yarns are mixed, but their use is inevitably increasing as the tedious processes of hand cleaning and carding one's own wool, which were so vividly described by Reichard in the early 1930s, are no longer recognized by the new generation of weavers as a necessary part of their craft operations.

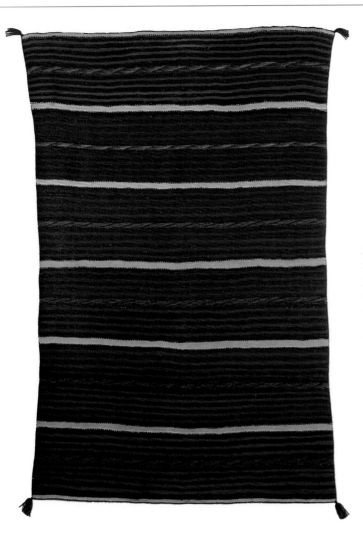

Plate 3. The "Moqui" pattern of narrow stripes in indigo blue, natural black or brown, and white was probably introduced by the Spaniards in the seventeenth century. Stripes of other colors, most often red, are sometimes found in late Classic or Transitional Moqui-pattern blankets, such as this one from the 1870s. 72" x 45" (SAR T.109).

Plate 4. Fragments of belting from a Navajo burial near Canyon de Chelly, 1800–1850. (Courtesy Maxwell Museum of Anthropology, catalogue nos. 66.46.6A [*left*] and 66.46.1 [*right*]; photo by Deborah Flynn.)

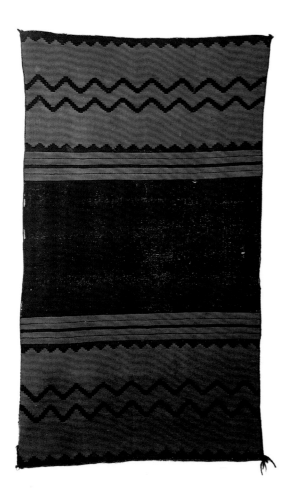

Plate 5. Half of a woman's two-piece dress with simple pattern of terraced lines in indigo blue set in a red ground. The red yarns were raveled from cloth dyed with a mixture of lac and cochineal. 1850–1860, 52" x 30" (SAR T.69).

Plate 6. Woman's shoulder blanket with tapestry-patterned borders reproducing dress designs. The entire piece is woven in over-two under-two diagonal twill. 1870–1880, 40" x 61" (SAR T.355).

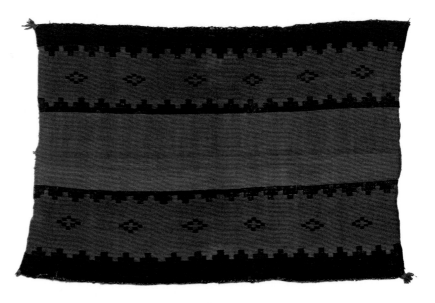

Colors and Dyes. The natural tones of churro wool supplied the Classic period Navajos with white and a range of blackish-brown and light brown shades, greys, and tans. Other shades of grey and tan could be produced by carding dark and light fibers together. Vegetal indigo, one of the principal trade items brought into the Rio Grande Valley from Mexico, was used extensively by both Pueblos and Navajos to get a range of blue colors, and in combination with a yellow dye extracted from native plants, it created shades of green. The black dye known to the Pueblos was probably also employed by the Navajos of the Classic period, as it has been in recent years, to intensify and even the color of natural dark yarns (Reichard 1936:46). It is really an ink made by boiling the twigs and leaves of the sumac (*Rhus trilobata*) and adding roasted, powdered yellow ochre and piñon pitch. A reddish-brown dye extracted from an unidentified plant and used for both cotton and wool textiles by the Hopis in the early 1700s (Kent 1979:6) was probably known to the other Pueblos and to the Navajos as well.

To this limited palette was added the clear red of bayeta, dyed with lac or cochineal. Both substances give crimson or bluish-red tones rather than the orange-reds of the synthetic dyes used after 1870 (compare plates 1 and 9). Lac is an Old World dye made from a resinous substance formed by a scale insect on certain trees in the Near East and southern Asia. Cochineal is extracted from the body of a small insect that lives on the prickly pear cactus in Mexico. It was imported to some extent into the Rio Grande Valley and used by Spanish weavers there, but has so far not been definitely identified on any handspun Navajo or Pueblo textile. Concerning this point, Wheat writes (letter of June 7, 1982), "I have never seen a Navajo native spun yarn dyed with cochineal, nor have I ever found any documentary evidence that they even used cochineal. Documents in the 1865 period flatly state they dye only with indigo, using yarn and bayeta for all other colors."

The combination of natural blackish-brown, white, and indigo blue handspun yarns, raveled red, and occasional touches of handspun dyed yellow or green characterizes Navajo Classic period textiles (plate 1). Toward the end of the period, between 1850 and 1865, Saxony yarns in a wider variety of colors came into fairly common use, thus contributing to a change in the conservative nature of Navajo textile design.

Like the yarns of the time, Transition period dyes are a rather mixed lot. Handspun yarns in natural tones, indigo dyed, or dyed with native yellow or green still appear, but synthetic-dyed handspun and raveled yarns are also

found on some blankets of the 1870s. Pink yarn, produced by carding native white wool fibers with waste materials from red commercial cloth, is especially characteristic in blankets of the 1870s.

Packaged "Diamond Dyes" were furnished to the Transition period Navajos by Wells and Richardson of Burlington, Vermont. They required no extra mordant, but could simply be added to the water in which wool was immersed for dyeing. Red-dyed handspun soon replaced raveled red, and natural brown and black wools were overdyed with synthetic black to produce a more even shade. Although it was stocked in some trading posts until the early 1900s, vegetal indigo gradually fell from use after the 1880s, probably because synthetic dyes were easier to handle. In addition to red in many shades, bright orange, yellow, purple, and green were popular in the late 1800s, and many textiles of the time show a rather unrestrained use of color.

From the Transition period to the 1940s, it is not unusual to find blankets in which the dyes are uneven or streaked because the color has not taken well on the handspun wefts (fig. 28). The principal cause of this is the poor quality of the wool from mixed-breed sheep. It was apparent by the 1920s, however, that dyes as well as wool must be improved if the overall quality of rugs was to be upgraded. Mary Cabot Wheelwright, a Bostonian

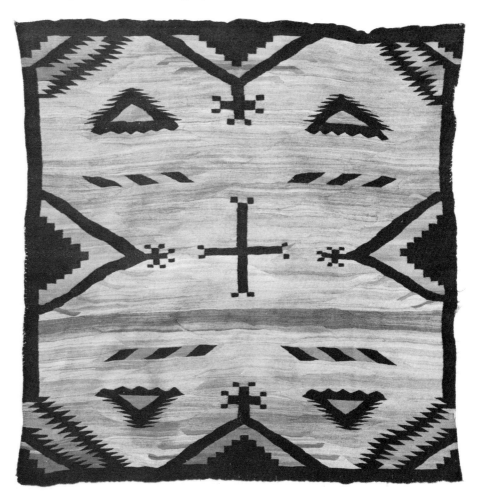

Figure 28. The streaked gold-tan-brown background color of this rug probably resulted from poorly handled dye that did not take evenly on the inferior yarns. The black and red motifs "float" on the rug's surface in a manner characteristic of rug design in the early 1900s. 80" x 80" (SAR T.400).

interested in Indian arts and active in the Eastern Association on Indian Affairs, visited Canyon de Chelly in 1920 and apparently was horrified at the poor grade of the rugs brought in to the trading post there for sale. With the cooperation of the local trader, L. H. (Cozy) McSparron, his wife, Inja, and Camille Garcia, trader at nearby Chinle, Miss Wheelwright launched a crusade to improve dye colors.

The problem was attacked from two angles. An effort was made on the one hand to obtain better synthetic dyes for the weavers, and on the other to develop vegetal dyes. DuPont cooperated in the first approach by making up a set of colors softer in tone and more pleasing than those already in use (plate 22). They were more expensive than Diamond Dyes, and difficult to handle as color and mordant were packaged separately. The Navajos did not accept them, so Inja McSparron undertook to dye wool for the weavers for a time.

In another experiment, in about 1943, the Wingate Vocational High School sent wool to Texas Tech University in Lubbock to be cleaned, spun, and dyed with chrome dyes. About seventy rugs were woven of this yarn before the operation ceased (Erickson and Cain 1976:71). The solution to the problem of synthetic dyes finally came when Wells and Richardson devised a new set of packaged dyes, to be handled in the same manner as the original ones but producing softer tones. Called "Old Navajo," they are still used but are now produced by W. Cushing and Company (fig. 29; Reichard 1936:29–30).

The idea of extracting dye colors from local plants was adopted by Nonabah Bryan, a Navajo woman teaching at Wingate Vocational High School in the 1930s, who, with Stella Young, published a pamphlet (Bryan and Young 1940) containing formulas for some eighty-six shades. Other Navajo women have nearly doubled this number through experimentation.

Figure 29. Two packages of dye made specifically for the Navajo trade by W. Cushing and Company of Kennebunkport, Maine. (SAR 1982-3-6; photo by Deborah Flynn.)

At the present time Navajo rugs are being woven of many different kinds of yarn, and it is possible to buy rugs containing either synthetic- or vegetal-dyed fibers, or a combination of the two. Native sheep wool that has been clipped, cleaned, carded, and handspun in the traditional manner is still to be found in some rugs, although commercially scoured, carded, and sometimes dyed Navajo wool is more common. Commercially spun and dyed yarns that closely resemble native single-ply handspun are increasingly being used, as are four-ply Germantown yarns. It is these new materials rather than modifications in technique or even in design that make contemporary Navajo rugs so different in appearance and texture from those of the early 1900s and from Classic and Transition period blankets.

Looms are still constructed in the traditional manner, although milled lumber and iron pipe may replace the rough-hewn wood formerly used for uprights and loom beams. Weaving tools and procedures are basically unchanged, and the three common textile techniques are still plain-weave tapestry, twill weave, and warp-faced and warp-float narrow-band weaving.

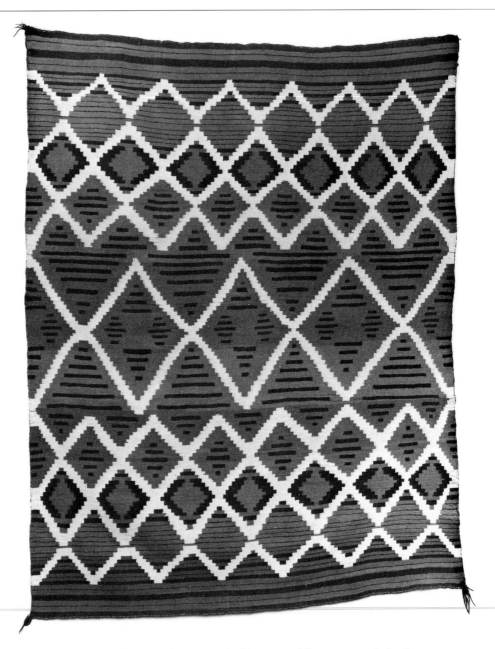

Figure 30. The network pattern of white terraced lines on a raveled red ground, along with the small bars of indigo blue, suggest that this Classic period serape was woven between 1850 and 1860. 65" x 51" (SAR T.8).

The Classic Period: 1650 to 1865

The term "Classic" is used here to mean "traditional" in three senses: the textiles woven prior to 1865 served the autonomous Navajos' own needs; the terraced tapestry patterns on dresses and blankets evolved from their own simple, right-angled basketry designs without the intrusion of a foreign aesthetic; and the principal material used was wool from the weavers' own sheep, which they carded, spun, and dyed themselves. While there were changes in textile materials and patterns toward the end of the period, these were the result of the Navajos' own selections from among new yarns and designs introduced from Mexico and the United States.

Information gleaned from archaeological remains of the late 1700s and early 1800s, along with the scant historical references to early Navajo dress, makes it clear that the Navajos adopted the textile types of their Pueblo neighbors at the time they learned to weave on Pueblo-type upright looms, probably before 1700. For about a hundred years, Navajo and Pueblo textiles were almost identical in technique, form, function, materials, and many aspects of design. Both groups wove wider-than-long mantas, wool shirts, breechcloths, and belts for their own use. Both knew plain, twill, and alternating-float weaves, and both utilized handspun wool in natural colors and also dyed with indigo and some vegetal yellow. Raveled reds, either lac or cochineal dyed, appear in the oldest surviving Navajo pieces, and the Navajos also used a brownish-red plant dye, possibly the same as that of the early Hopis.

From the start of the Classic period, Spanish weaving influenced both Navajos and Pueblos. With the exception of indigo dye, introduced from

Mexico in the 1600s, this influence was felt not so much in techniques as in the appearance of loom products, since both groups made Spanish-style longer-than-wide serapes for their own use and for trade (fig. 30).

No examples of Navajo clothing have survived from the 1600s, and there are very few pieces from the 1700s. The oldest known fragments are those of a shirt and a belt from a child's burial in the Gobernador Valley, dated by tree rings to between 1730 and 1750 (Kent 1965:113–16). Textiles woven since about 1800 have been preserved in greater quantities. The oldest of these include about a dozen complete examples, as well as a few scraps, of mantas, dresses, serapes, and bits of belting, all from Massacre Cave and other sites in the Canyon de Chelly–Canyon del Muerto region (Amsden 1949:plate 63; Kent 1966:46–60; Tanner and Steen 1955:110–18; Wheat 1977:425–27).

The shirt from the Gobernador burial was of plain-weave brown wool with green stripes. All that remains of it is a few small fragments, so its original pattern cannot be determined, but it was probably like those worn by Navajo and Pueblo men in early historic times (see Amsden 1949:plate 33b). Perpetuating an aboriginal style, weavers fashioned these shirts from three separately woven cloths: a large rectangle with a head slit at its center served as the body, covering the wearer's front and back to below his hips and held in place by a belt; smaller cloth rectangles were fastened at the shoulders to serve as sleeves whose edges were loosely tacked together under the arms. Shirts were often woven of indigo blue yarns with diagonal-twill centers and diamond-twill borders. By 1850, some were patterned by red stripes.

A blue wool shirt was found on the body of an elderly Navajo man in a cave burial dating to the late 1700s in the Canyon de Chelly region. With it were a brown-and-white-striped manta-shaped blanket, a black manta with indigo blue diamond-twill borders, and deerskin leggings with "woven garters" (Amsden 1949:98, plate 63). Neither the shirt nor the garters was collected, and we know only that the former was V-necked. One assumes that the garters were warp-faced ties, probably with alternating-float-weave center panels, like other narrow bands found in sites dating between 1730 and 1850.

Several partial belts of the type that would have been worn with the simple wool shirts have been preserved. The Gobernador burial yielded what appear to be warp-faced belt fragments of indigo blue and brown yarns, and there are at least three other fragmentary Classic period belts in existence,

two from an early site near Canyon de Chelly and one, possibly mid-1800s in date, retrieved from a burial destroyed by a flood in Canyon del Muerto in 1941 (Tanner and Steen 1955). The Canyon del Muerto belt and the three fragmentary blankets salvaged with it were badly damaged by moths while in storage, so that when analyzed in 1955 the "sash [was] almost completely gone; there was scarcely a piece 1 inch square left" (Tanner and Steen 1955:110). The belt measured about eight and one-half feet long by two inches wide when found. Its ends were tapered by twisting adjoining warps together, thus reducing the width of the piece. From one outside edge of the belt to the other, warp stripes in the following color sequence were recorded: black, red, black-and-white float weave, red, and black. All yarns in the piece are described as handspun z-spun wool. The nature of the red dye is not recorded, nor do we know whether the black yarn was dyed. White wefts number eight to the inch; warps average between thirty-eight and forty per inch. Tanner's analysis of the weave in the center black-and-white panel is not clear, understandably so since she was working with such limited evidence, but she leaves little doubt that it is a float weave, since the weaver "exposed warps to create patterning" (Tanner and Steen 1955:117).

One of the two belts from the early 1800s burial near Canyon de Chelly has a clearly defined pattern of indigo blue warp floats against a plain-weave white ground (fig. 31). The second (plate 4, specimen 66.46.1), incomplete in width, has white wefts and a half-inch blue-and-white stripe of alternating float weave down what must have been the center, with narrow stripes in a sequence of brown, red, brown, green from the center to an unfinished edge. The red yarn, dyed a rather pale ochre with an unidentified vegetal dye, is single ply and z-spun.

The other fragments in the Canyon de Chelly find may be weft-faced blankets with narrow stripes or bits of warp-faced belting. The colors in these pieces include greens that appear to have been produced by combining indigo and yellow dyes, and three lac reds. One is a raspberry red on a tightly z-spun yarn (plate 4, specimen 66.46.6A); another is a rust red on extremely fine, slightly s-spun, raveled yarns used in pairs; and the third is a very bright red appearing on z-spun raveled yarns used in pairs in a brown wool blanket fragment.

The Navajos wove four types of mantas in the Classic period: black mantas with indigo blue diamond-twill borders, which they called "blue borders"; white mantas with indigo blue diamond-twill borders ("maiden

Figure 31. A fragment of an indigo blue and white handspun wool belt from the vicinity of Canyon de Chelly, Arizona, 1800–1850. (Courtesy Maxwell Museum of Anthropology, catalogue no. 66.46.3; photo by Deborah Flynn.)

shawls"); mantas with tapestry-patterned bands or borders flanking a solid-color center ("fancy mantas"); and mantas patterned by weft stripes, a type that became famous in the literature as the "chief blanket."

Chief blankets are perhaps the best-known products of Classic and early Transition period Navajo looms (Wheat 1976c). Those woven in the Classic period are, as a group, technically superior in weave, with finely spun wefts, tightly battened. Calling them "chief blankets" implies that only recognized tribal leaders could wear them, but in fact anyone could own such a blanket, and they were traded widely to other Indians in the Southwest and out onto the Great Plains (K. Bennett 1981). As Amsden (1949:100) says, however, "while never in a strict sense a badge of chieftainship, this garment did have a certain connotation of power and affluence wherever seen."

Frederic H. Douglas (1951) was the first to outline the evolution of design in striped shoulder blankets, describing it in terms of five phases, which have since been consolidated into four. As he pointed out, the development of design from simple to complex is not a step-by-step progression, and it bears only an approximate relation to the passage of time.

The very earliest striped mantas, from the late 1700s and early 1800s, were patterned by narrow white stripes alternating with stripes of natural black or brown. This simple system began to be elaborated after 1800 into what are called "Phase I" patterns (fig. 32), the first of the four types popularly recognized at present. Because these phases overlap considerably, Transition as well as Classic period types are included here. The phases have been delineated by Wheat (1977:428–29) in the following terms:

Figure 32. The simple stripe pattern in natural white, black, and indigo blue is typical of Phase I chief blankets. This is probably the type illustrated in figure 4. 1800–1850, 60" x 69" (SAR T.304).

Phase I, 1800–1850. These blankets are patterned by wide black and white stripes, with the two border stripes somewhat wider than the others and the black center stripe of double width. When the blanket is wrapped about the wearer's shoulders, this stripe is seen as a broad band or belt at his waist. The border bands sometimes include pairs of narrow indigo blue stripes, and two pairs of blue stripes may appear on the center band. The indigo stripes were occasionally bordered by very narrow lines of raveled red. This slightly more colorful version of the Phase I pattern is said to have been especially in demand by the Utes (Amsden 1949:100). Fragments of such blankets were found in Massacre Cave, dating the adoption of Phase I patterns to 1804 or earlier.

Phase II, early 1800s–1870. Small red bars or rectangles of red were woven into the ends and centers of the blue stripes in this type of blanket, thus creating twelve spots of color (plate 7).

Phase III, 1860–1880. Here the six spots or bars of color in the center stripe merge into three, and we have the nine-spot layout. This usually consisted of a terraced-edge diamond at the center of the broad middle band, quarter-diamonds at each corner of the manta, and half-diamonds at each end of the broad center band and at the middle of the border bands (plate 8).

Phase IV, 1870–1885. This phase covers the increasingly elaborate shoulder blanket designs of the Transition period (fig. 33). Sometimes the diamond

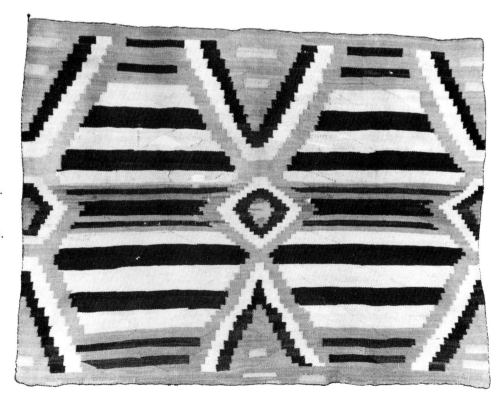

Figure 33. Rug with a Phase IV chief blanket pattern, probably woven at Hubbell's Trading Post. Collected in Manitou Springs, Colorado, between 1896 and 1903. 59" x 81" (SAR 1981-8-3).

Plate 7. The distribution of the small red bars within the center and edge stripes create a typical Phase II pattern on this chief blanket, which probably dates between 1850 and 1860. 58" x 76" (SAR T.46).

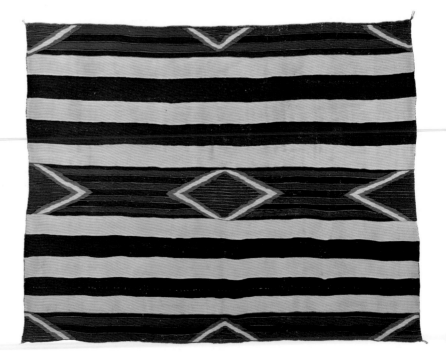

Plate 8. A man's shoulder blanket with a Phase III chief pattern, probably woven in the 1860s. The warps are commercial three-ply white wool yarn, and the raveled red may be presynthetic. 58" x 76" (SAR T.328).

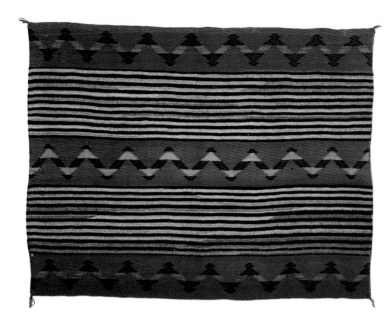

Plate 9. A woman's shoulder blanket woven in the 1870s. 46" x 62" (SAR T.4).

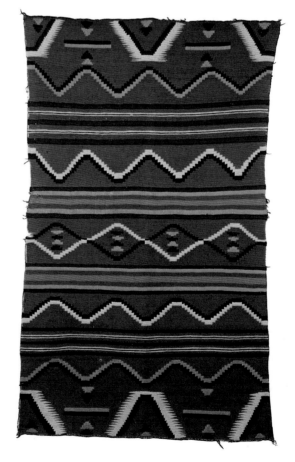

Plate 10. The terraced pattern on this child's shoulder blanket dates from the Classic period, but the serrate edging on the half- and quarter-diamond motifs at both warp borders shows later Saltillo influence. Dyes on the raveled red and green yarns are probably synthetic. 1865–1875, 52" x 33" (SAR T.531).

figure in such a piece is so large that stripes are reduced to mere background. Or serrate motifs replace Classic terraced designs. Elaborations such as pictorial motifs are sometimes woven into the blankets, replacing geometric designs. Since the late 1800s, rugs with chief blanket patterns of any phase have been produced.

Women's striped shoulder blankets are smaller than men's. They are usually patterned with very narrow alternating grey and black stripes between the broad center and outer bands (fig. 34, plate 9). The bands generally contain meanders, crosses, or zigzag patterns, although a few do show the nine-spot Phase III layout of diamonds of late Classic times. Women's blankets with Phase I and II patterns are rare, and it is apparent that striped blankets were not widely used by women until the Transition period. Prior to that time, blue-bordered or tapestry-bordered mantas or serapes must have served.

The manta found with the late-eighteenth-century man's burial in Canyon de Chelly is of the type Navajos call "blue borders." These are identical in appearance to the black wool diagonal-twill mantas with indigo blue diamond-twill borders worn by Pueblo women as both wraparound dresses and shoulder blankets since earliest historic times, perpetuating the cotton manta-dress of pre-Spanish days. "Blue borders" mantas similarly served Navajo women as both dresses and shawls until the late 1700s, and Navajo men and women continued to use these mantas along with other kinds of shoulder blankets through the Classic period. Navajo women wove "blue borders," probably only for sale to Pueblo Indians, into the 1900s (fig. 35).

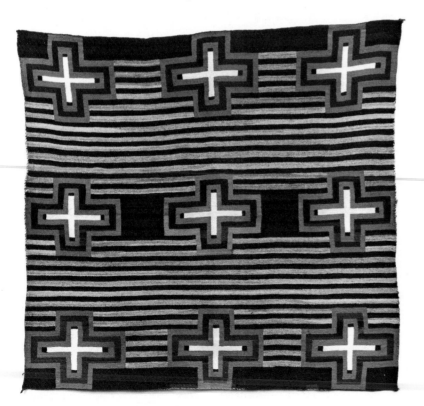

Figure 34. Woman's shoulder blanket of the 1870s with a modified Phase III pattern. 52" x 56" (SAR T.361).

While these and other Navajo-woven blue-bordered mantas look superficially like Pueblo pieces, examination shows that they depart from the rigid Pueblo formula established, judging from fragments found at Walpi, at least by the early 1700s. This formula governs such technical details as the composition of the selvages, the type of binding stitch separating the borders from the center section, and the unvaried use of diagonal twill for the center and diamond twill for both borders (Kent 1983c:62–65). In the Navajo mantas, lazy lines interrupt the diagonal-twill rhythm and selvages follow a Navajo formula. There may be no binding stitches at all, or non-Pueblo stitches may outline the diamond borders. The mantas may even be of diagonal twill throughout.

In the 1700s, the Navajos probably adopted another type of traditional Pueblo manta, the "maiden shawl," woven in white diagonal twill with indigo blue diamond-twill borders, and sometimes red diagonal-twill stripes inside the blue borders (see fig. 46). A small fragment of such a manta was used as one of the patches on a worn plain-weave shoulder blanket from an undocumented Navajo burial in the vicinity of Canyon de Chelly, probably dating to about 1800 (Kent 1966:52–54). While the fragment could be of Pueblo manufacture, the one remaining corner is finished in typical Navajo fashion: white weft selvage strings are knotted together and additional lengths of blue and white string are looped through the fabric inside the knots to make a small tassel (fig. 36). This type of manta may have had ritual

Figure 35. A "blue borders" manta probably woven in the late nineteenth century but collected at Tesuque Pueblo in the 1930s. Lazy lines within the diagonal-twill center and other non-Pueblo characteristics indicate that the piece was Navajo woven. 43" x 50½" (SAR T.707).

Figure 36. A fragment suggesting a "maiden shawl" found as a patch on a blanket from a burial near Canyon de Chelly, Arizona, and probably dating to the early 1800s. (Courtesy Museum of Northern Arizona, catalogue no. 2265/E2004; photo by Dick Weston.)

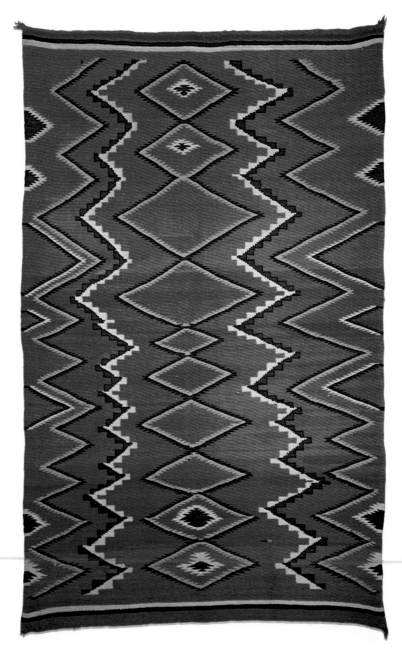

Plate 11. A Transition period blanket woven of aniline-dyed handspun and raveled yarns, showing influence from the Saltillo design system in the vertical layout of the pattern. 1870–1885, 74" x 47" (SAR T.670).

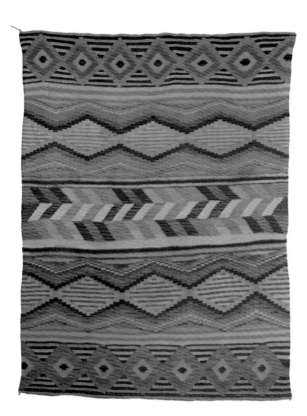

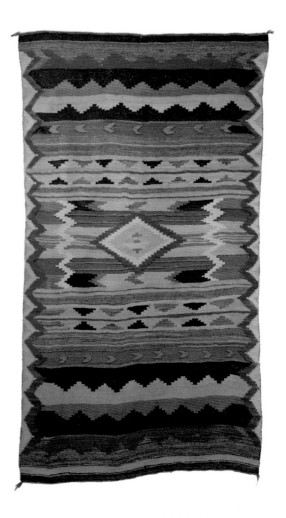

Plate 12. The range and combination of colors in this 1870s blanket give it a Rio Grande Spanish "feel," although the terraced motifs are Navajo. It was woven on an upright loom, and its continuous warps and lazy lines mark it as Navajo work. 75½" x 57" (SAR T.343).

Plate 13. Combining the two-ply warps and colors typical of Rio Grande blankets with terraced design motifs reminiscent of Navajo work, this blanket appears to have been woven on the upright Navajo loom. About 1880, 85" x 49" (SAR T.333).

significance among the Classic period Navajos, as it is said to have been part of a costume worn during the yeibichai dance (Wheat, personal communication, 1982). One of the Navajo men at Bosque Redondo pictured in figure 5 is wearing what may be a white manta with indigo blue borders.

Late in the 1700s, the two-piece wool dress became fashionable among Navajo women, replacing the one-piece, blue-bordered manta-dress (fig. 37; see also fig. 6). This distinctive garment, inspired perhaps by deerskin dresses or by Spanish-style serapes, consists of two matching plain-weave blankets longer than they are wide. One piece serves as the front panel of the dress, the other as the back. They are sewed together up the sides to a little above the waist, held at the waist by a warp-patterned belt, and fastened together at both shoulders.

Following the Pueblo aesthetic for manta-dresses, the Navajo version was woven of black or brown wool with deep decorative borders at top and bottom. But whereas the borders of Pueblo mantas were either woven in diamond twill or decorated with embroidery, those of Navajo dresses originally were simple indigo blue stripes. Raveled red was later added as it became available (plate 5), a design style that continued into the Transition period. Half of a woman's dress found in Massacre Cave (Amsden 1949:

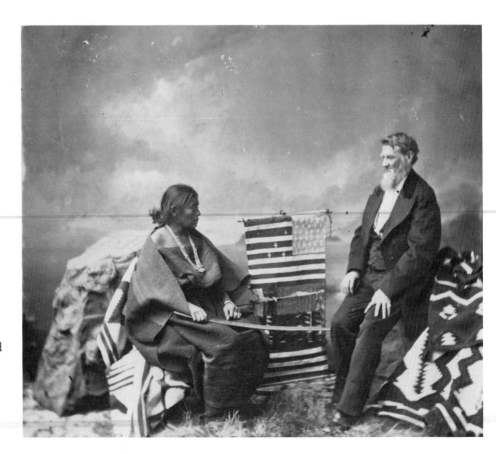

Figure 37. Juanita, wife of the chief Manuelito, photographed with Navajo agent Arny in 1874. She wears a two-piece wool dress and a tapestry-bordered manta, and holds a batten. An unfinished flag blanket, one of the earliest recorded pictorials, is on the loom. (Courtesy National Anthropological Archives, Smithsonian Institution, photo no. 2405.)

plate 49) indicates that further elaboration of the borders had occurred by the early 1800s, when terraced tapestry patterns were woven into some of them. The only characteristic adapted from Pueblo embroidery that is found in Classic Navajo textiles is what has been called "negative" design. As expressed in embroidery, this means that the entire background is filled with color except for small bits of the ground cloth left to form the pattern. In Navajo tapestry-woven dresses and some mantas, negative design is achieved by weaving small units of dark indigo blue within the red borders (fig. 38).

A distinctive kind of manta that Wheat (1976a:11) called the "Fancy Manta" was also a product of the Classic period and continued to be made in the Transition period. Fancy mantas, either twill or plain weave, have solid-color centers flanked by bands containing stripes or tapestry-woven design motifs identical to those on two-piece dresses (fig. 39, plate 6). The earliest recorded example probably dates to about 1850 (Wheat 1977:429), and both Navajo men and women were photographed at Bosque Redondo wearing such mantas as shoulder blankets. They look to me like a Navajo version of the black mantas with red embroidered borders of late Classic-period Acoma and other New Mexico pueblos.

Though the primary influence on early Classic period Navajo weaving was Pueblo, materials and designs introduced by Spaniards also had their effect. From the 1600s on, Indian weavers produced Spanish-style, plain-weave, weft-faced blankets in which the longer dimension parallels the warps. These longer-than-wide blankets may be called "serapes" to distinguish them from the indigenous wider-than-long shoulder blankets, which have been

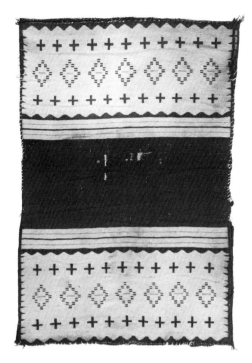

Figure 38. Indigo blue elements on a background of raveled red yarns exemplify the Navajo adaptation of negative designing. On this dress, paired bars take the place of the solid squares that usually form the stepped outlines of a diamond figure. 1860– 1870; each half, 50"x 34½"(SAR T.372).

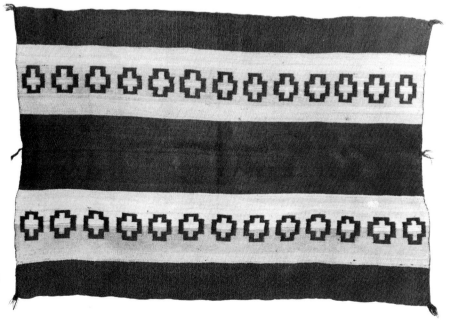

Figure 39. Both the pattern of crosses and the presence of lazy lines within the brown diagonal twill center of this woman's manta mark the piece as Navajo woven. 1870–1880, 38" x 56" (SAR T.7).

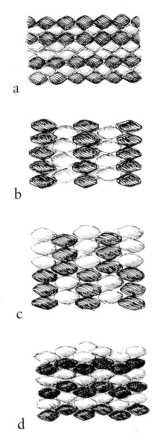

a

b

c

d

Figure 40. Simple self patterns made by inserting colored wefts in planned sequence. *a*, Beading. *b*, Vertical bars or lines. *c*, Checkerboarding. *d*, Wavy lines.

termed "mantas" in this book. Serapes were used as shoulder robes and sleeping blankets, and were important to the Navajos as trade items from the early 1700s until the late 1800s. Three types of Classic period serapes may be distinguished: Moqui-pattern blankets, coarse "diyugi," and finely woven serapes with tapestry patterns.

Moqui-pattern blankets (plate 3) are characterized by very narrow alternating stripes of indigo blue and natural brown or black, often organized in bands and separated by narrow white stripes. These blankets are usually technically superior in evenness of weave, closeness of wefts, and fineness of yarns. The term "Moqui" is an old name for the Hopis which dealers applied to the blankets on the assumption that they were of Pueblo manufacture. Small fragments of the type have indeed been found in eighteenth-century Walpi Pueblo, and we know that the Hopis and other Pueblos did weave this pattern in the 1800s. It is probable, however, that the pattern originated with the Spaniards, who introduced it into the Southwest along with the serape shape, indigo dye, and wool. Moqui-pattern blankets were woven by Navajos, Pueblos, and Rio Grande Spaniards alike through the Transition period.

"Diyugi" ("soft, fluffy weave") is the term Navajos apply to serape-shaped blankets made for everyday use. Loosely woven from rather thick, soft yarns, they were originally patterned by simple stripes of natural brown on a white ground. The edges of the stripes were often decorated by beading or checkerboarding, or the stripe might consist of small vertical lines of color (fig. 40). In some diyugi, stripes of different widths or solid and wavy-line stripes are grouped into wider bands. All these uncomplicated but effective ways of lending interest to simple banded designs are based on the particular order in which white and brown wefts are woven into the blanket. The various patterning devices found on diyugi were part of the weaving repertoire of the pre-Spanish Pueblos, and also appear on bits of a Navajo diyugi from Massacre Cave (fig. 41). It is safe to assume, then, that the formulas for

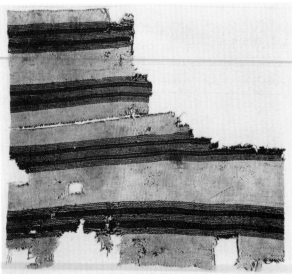

Figure 41. Fragment of a blanket from Massacre Cave woven of natural brown and white handspun yarns in bands of solid and wavy-line stripes. Late eighteenth century, complete width 54". (Courtesy Maxwell Museum of Anthropology, catalogue no. 63.34.69; photo by Deborah Flynn.)

producing them were acquired by the Navajos when they first learned to weave.

Some of the finest Navajo textiles are the serapes patterned with bold terraced or stepped tapestry motifs that were made from the early 1800s through the end of the Classic period (plate 1, see also fig. 30). Together with chief blankets, these are considered the outstanding examples of Navajo Classic period weaving skill, with yarn counts averaging 50 but ranging up to 120 wefts to the inch. A few fine old serapes were woven like Mexican ponchos, with a long, vertical center slit for the head. It is important to reiterate here a point made in the discussion of technique, namely that the Navajo practice of battening wefts so closely that warps are totally concealed is a logical corollary to the development of increasingly complex plain-weave tapestry patterns from 1800 to the present time.

The terraced designs on early Classic serapes resemble those on Navajo dresses (fig. 42). Although the main lines of the pattern continued to be horizontal, as in the simple stripe arrangements of diyugi and Moqui-pattern blankets, motifs came to be combined in increasingly involved ways toward the end of the Classic period (Wheat 1977:430–31). In most Classic designs, the background color and motifs are balanced so that both are intrinsic parts of the total pattern. Patterns are worked in indigo blue and white, with touches of native vegetal yellow or green on a crimson bayeta ground.

The increasing use after 1850 of commercial yarns such as Saxony in a variety of new colors contributed to the growing complexity of serape patterns. The most significant changes in Classic period Navajo textile design, however, came as a result of influence from Mexico. Mexican blankets were imported into the Rio Grande Valley from about 1800 to 1850, principally from the northern weaving center of Saltillo. Their designs were reproduced in somewhat simplified form by local Hispanic weavers.

It has been suggested that some of the Rio Grande blankets issued to Navajos at Bosque Redondo may have been patterned in Saltillo-derived designs, and that this circumstance may have prompted Navajo weavers in substantial numbers to adopt Saltillo motifs. In any event, the influence of these designs is evident in late Classic textiles and becomes increasingly important in Transition period pieces. Characteristically, the creative Navajos drew certain design ideas that appealed to them—in particular the center-dominant figure and serrate motifs—from these blankets rather than copying

Figure 42. Terraced motifs of the Classic period.

Figure 43. Motifs derived from Saltillo-style blankets.

them wholesale (fig. 43). They enlarged the small geometric motifs into significant parts of a pattern, or even made them the sole design on a blanket.

The blanket shown in figure 44, woven on a Spanish loom in the Rio Grande Valley, illustrates the essential components of Saltillo design that were reflected in Navajo textiles. The layout is characterized by a center-dominant diamond figure set against a background of vertical panels. The central diamond is outlined by serrate lines, or lines composed of small, sharply pointed triangles, rather than the right-angled terracing of Classic Navajo design. In many Saltillo blankets, the vertical background panels are made up of repeats of a single motif, while in others, small motifs float at random on the background rather than being organized into panels. The borders at the ends of the blankets are ordinarily solid color, with the side borders figured like those shown here.

While the influence of Saltillo design is more pronounced in Transition period serapes than in those of the late Classic period, it can be seen in some of the latter, such as the Chief White Antelope blanket (plate 2), woven between 1860 and 1863. The center-dominant diamond figure and the vertical zigzag lines positioned as side borders suggest the Saltillo scheme, as do the sharp pointed-line motifs at the edges of the blanket's center. Individual motifs have terraced rather than serrate outlines, however; and the background is composed of several different figures, each type repeated within its own horizontal band.

Classic period textiles reflect the nature of the Navajos' contacts with other cultures but also offer visual evidence of their essential independence and individuality prior to Bosque Redondo. The evolution of chief blanket designs is one example of the creativity shown by Classic Navajo weavers. During the decades when the people were autonomous, they followed their own aesthetic, developing forms and designs they found pleasing. Their departures from strict Pueblo textile conventions probably also reflect the fact that weaving was not an ancient art among the Navajos, so weavers were not constrained by tradition to reproduce textiles made in accordance with established rules. Even so, it is interesting that major changes in Classic period textile design appear not on articles of traditional clothing woven for the use of Navajos or other Indians, but on serapes destined principally for trade with Spaniards and Anglo-Americans.

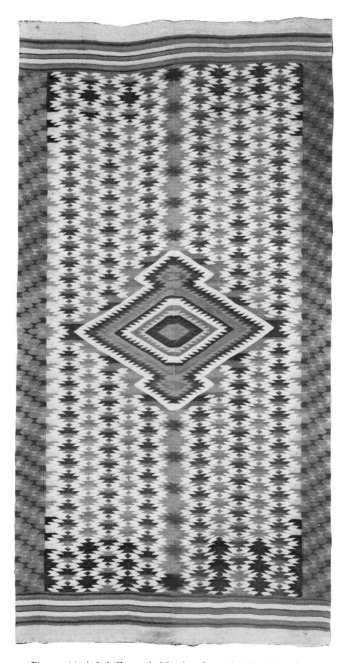

Figure 44. A Saltillo-style blanket from the Rio Grande Valley, about 1870. 93" x 49". (Spanish Colonial Arts Society, Inc., collection on loan to the Museum of New Mexico, catalogue no. L.5.62.84; photo courtesy Museum of International Folk Art.)

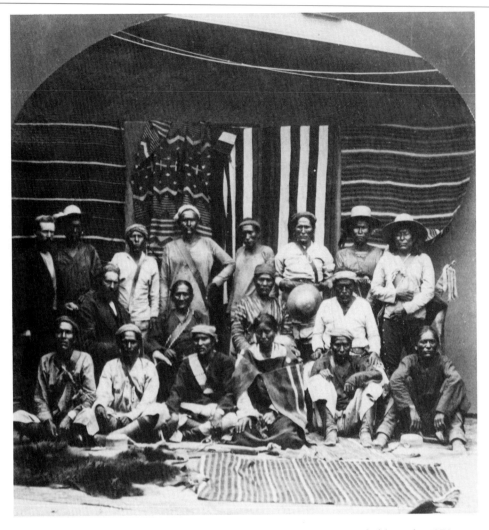

Figure 45. Northern Arizona Navajos and some of their blankets, probably in the 1870s. Shown in the photo are Moqui-pattern and terraced serapes, a Phase I chief blanket, and a striped diyuge. (Courtesy National Anthropological Archives, Smithsonian Institution, photo no. 54621; photo by C. R. Savage.)

The Transition Period: 1865 to 1895

The forced exile at Bosque Redondo marked a turning point in the Navajos' history, and the ensuing thirty years, called the Transition period, were a time of major change in their textiles. The weaving of clothing and blankets gradually gave way to the production of rugs for an off-reservation market, and Navajo weavers turned from following their own aesthetic to producing patterns compatible with the tastes of traders and patrons, primarily Anglo-Americans.

Through the early years of the Transition period, Navajo women continued to weave most of the textile types they had made in Classic times (fig. 45). These included two-piece dresses, belts and ties, serapes, and mantas of several types. Horse trappings—single and double saddle blankets, saddle throws, and saddle cinches—also became important loom products after Bosque Redondo. As time went on, weavers experimented with new yarns, dye colors, and weave techniques. The results included eye-dazzlers and Germantowns, with their explosive patterns, and wedge weaves, double cloth, and two-faced weaves of uncertain technical origin.

Most Transition period mantas were weft-striped chief blankets, but fancy mantas, black mantas with indigo blue diamond-twill borders, and white mantas with blue (or sometimes blue and red) borders also continued to be made. I suspect the last three types were produced by enterprising Navajo women to fill needs of the Pueblo Indians that the dwindling number of Pueblo weavers could no longer accommodate.

A number of Navajo-woven white mantas with blue and red borders, the type called "maiden shawls," are found in museum collections, often

credited to Pueblo weavers. The single example at the School of American Research (fig. 46) is indifferently crafted in plain weave and matches the description of mantas formerly made for the daily use of small Hopi girls (Wright 1979:17).

Some fancy mantas of the Transition period have centers of white, red, pink, or blue, with contrasting design bands, but most, like those of the Classic period, are black plain or twill weave with bands patterned in red. These garments were worn as shoulder blankets or wraparound dresses by the western Pueblo Indians from about 1850 to 1900. Since most were collected at Zuni or Hopi, they were at one time assumed to be of Pueblo manufacture (Amsden 1949:plate 87b; Kent 1983a:156–57; Mera 1949:6–18), even though the character of weaving and the design motifs identify them without question as Navajo.

Navajo women wove blanket-dresses throughout the Transition period, but most reserved them for "best" occasions after the 1880s, turning for daily wear to the full skirts and cotton blouses adopted at or shortly after Bosque Redondo. By about 1900, full skirts and velveteen blouses with silver buttons had become the "traditional" women's costume, replacing the blanket-dress completely (fig. 47). Even today, however, some families make a blanket-dress for a girl's initiation. Under Hubbell's direction at Ganado around the turn of the century, blanket-dresses were woven for sale to the eastern market (Hubbell, about 1902), possibly for use as portieres.

The same three basic kinds of serapes woven in the Classic period— diyugi, Moqui pattern, and tapestry patterned—were produced throughout the Transition period, but each was in some way elaborated. Tapestry-patterned serapes in particular became so diversified that for descriptive purposes they are further separated into types called wedge weaves, slave blankets, Germantowns, and pictorials.

Colored weft stripes often took the place of the standard brown stripes of earlier times in the coarse, everyday wearing blanket or diyugi. Sometimes

simple geometric tapestry motifs were incorporated within the bands of color (fig. 48). Diyugi were generally woven of thick, handspun, aniline-dyed wool yarns. Blankets of this type later furnished the inspiration for the weft-banded patterns of early vegetal-dyed rugs.

Transition period Moqui-pattern blankets often had large tapestry-woven motifs, frequently red in color, superimposed on the striped ground (fig. 49). The motifs seem to float on the banded background rather than being part of it. Hubbell favored the Moqui pattern, but rugs woven at Ganado under his direction in the late 1890s can be distinguished from earlier examples by the bright purple handspun or Germantown yarn used in place of the traditional indigo blue.

Some Navajo tapestry-patterned serapes woven between 1865 and 1880 retain the Classic pattern layout and terraced motifs but are dated to the early Transition period on the basis of the yarns and dyes they contain. Terraced and serrate motifs are combined in others (plate 10), and the latter come to dominate blanket design after 1880 or so. The main lines of the design may be placed vertically on the field rather than horizontally as in Classic period blankets (plate 11), or the pattern may be built around a dominant center motif—usually a diamond-shaped figure. These characteristics, inspired by the Saltillo design system, may still be seen in some modern textiles. After 1890, solid-color borders were often woven on all four edges of a blanket.

A few Transition period blankets were woven by an aberrant technique called "wedge weave" or "pulled warp" (Mera 1947:42–47), a variant of weft-faced plain weave in which wefts are battened at an angle, thus forcing warps out of their normal vertical position and resulting in slanted, rather than horizontal, weft stripes (fig. 50). The stripes slope up in one direction within a horizontal band and in the opposite direction in the adjoining band, producing a pattern of chevrons or vertical zigzag lines of color. Most wedge weaves contain very soft, thick yarns and have the feel of ordinary wearing blankets, but many are heavy enough to be designated rugs.

The earliest documented wedge weave, a "slave blanket," was made in the San Luis Valley of southern Colorado in 1876. The School of American Research collection also includes a small, undocumented wedge-weave serape (fig. 51), perhaps a child's shoulder blanket, that must date to the seventies or earlier. It contains two kinds of z-spun raveled yarn, probably synthetically dyed; a fine commercial three-ply red yarn; and white, indigo blue, and some greenish-yellow handspun. The quality is that of a Classic period blanket,

Figure 47. Navajo girls wearing the velveteen blouses and full skirts that became fashionable by about 1900. (Detail from painting by Harrison Begay, SAR P.292.)

Plate 14. The complex serrate patterning and fine outlining mark this as a technically superlative Germantown blanket. Both ends were once heavily fringed. 1885–1890, 81" x 56" (SAR T.95).

Plate 15. A pictorial rug probably woven between 1895 and 1920. 66½" x 41½"
(SAR 1963-4).

Figure 48. A simple banded pattern typical of the ordinary blankets woven of handspun yarns in the late Transition period. 1880–1890, 71" x 48" (SAR T.615).

Figure 49. The large red, white, and blue diamond motif superimposed on the stripes of this Moqui-pattern blanket suggests Saltillo influence. In the diamond's center is a small green cross, a motif probably derived from a woman's dress rather than from Christian symbolism. 1865–1875, 67" x 45" (SAR T.308).

with ten warps and fifty-two wefts to the inch. This is an average yarn count for the 1860s, but high for the seventies; the materials, on the other hand, are typical of the early Transition period. Most wedge weaves date to the 1880s, and the technique does not appear to have survived beyond the turn of the century except as an occasional experiment.

A particular class of blanket dating to the early Transition period retains the Classic design layout of horizontal stripes (sometimes with the addition of a central diamond) and employs terraced motifs, but displays some design elements, colors, and color combinations unfamiliar in Classic Navajo blankets (plates 12 and 13). Mera (1947:21) called these "slave blankets," which he defined as a "class of Southwestern blanketry in which there is a curious blending of Navajo upright loom technique and design with dyes and minor decorative motifs typical of those used by the Spanish colonists." Such blankets were supposedly woven by Navajo women living as slaves in Spanish households in the upper Rio Grande Valley. The women are assumed to have been taken captive in Spanish raids against the Navajos or to have been purchased from other Indian tribes, notably the Utes.

In the 1800s, many Spanish households in the northern Rio Grande

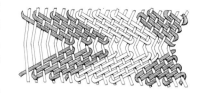

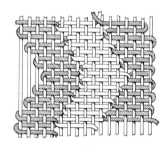

Figure 50. Two different methods of weaving a design of black and white chevrons: *above,* wedge weave; *below,* plain tapestry.

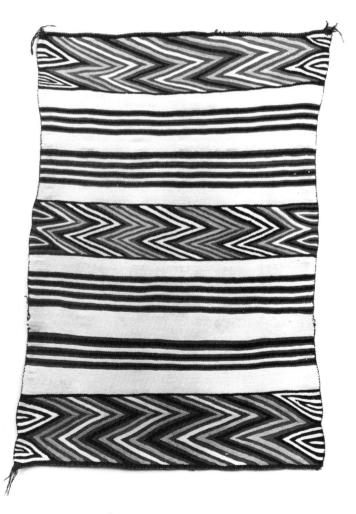

Figure 51. Probably woven in the early 1870s, this child's blanket shows bands of wedge weave at center and ends. 48" x 32" (SAR 1969-41).

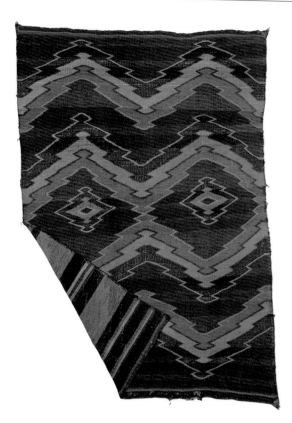

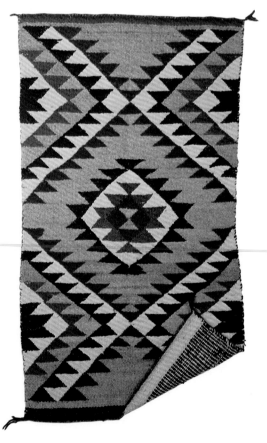

Plate 16. Commercial four-ply yarns in this two-faced blanket mark it as a typical Germantown, woven in the 1880s. The weave is open enough to allow the outlines of the surface pattern to show on the underside. 43" x 30" (SAR T.659).

Plate 17. One of two known Navajo double-weave rugs. It is essentially two separate textiles woven simultaneously but joined only at the selvages and at other random points. 1920–1940, 53½" x 31" (SAR T.393).

Plate 18. The deep, rich red, the combination of red, gray, and black, and the large central diamond motifs are all characteristic of modern Ganado-style rugs. 1950, 114" x 72" (SAR T.484).

Valley did indeed include Navajo women who performed household tasks, including spinning and weaving. These women were called *criadas*, a Spanish word that translates as "servant" or "maid" rather than "slave." Often such individuals were accepted as family members. There is no way of determining by looking at a blanket whether its maker was a criada or simply a Navajo woman who had seen Hispanic serapes and who had access to the particular range of synthetic dyes commonly selected by Rio Grande Spanish weavers. Only four blankets are actually documented as the work of Navajo criadas, and only one of these conforms to Mera's definition. This piece, the wedge weave mentioned earlier, was woven on an upright loom in 1876 by Guadalupe, a Navajo woman living with the family of Gaspar Gallegos in the San Luis Valley (Wheat 1979:plate 2). Two others of the four were woven in the 1870s, one at Abiquiu (Kent 1983a:fig. 3) and the other, a Moqui-pattern blanket, also in the San Luis Valley (M. Stoller 1979:44). Both of these, though they are the work of Navajo criadas, were woven on the Spanish treadle loom. Because it is unavailable for study, we do not know how the fourth blanket, collected in Torreon, New Mexico, was woven, so it is unclear whether it would meet Mera's criteria.

The School of American Research collection includes eight examples that conform in most respects to Mera's definition. Like Navajo blankets woven on vertical looms, they have continuous warps, four selvages finished with twisted yarns, and, in most cases, lazy lines. Their wefts are of single-ply handspun. Some have single-ply handspun warps as well, which is standard for Navajo blankets, but most have two-ply warps of the type characteristic in blankets woven on Spanish looms in the Rio Grande Valley. Their designs are essentially Classic period Navajo in style: the motifs are terraced, and the patterns are laid out in horizontal bands. Occasionally a blanket will contain Saltillo-like design elements. What really marks these textiles as atypical for the Navajos is the range of dye colors used on the handspun wefts and the ways in which the colors are combined. There are shades here that one simply does not associate with Navajo textiles, such as plum, lavender, violet, magenta, pale blue and green, soft pink, and apricot. If the blankets were indeed made by Navajo slaves or servants, their weavers either were selecting colors according to a Spanish aesthetic or were unable to find the dyes customarily used by the Navajos.

Most blankets in this category date to the 1870s; however, one in the School of American Research collection (fig. 52), classified as a slave blanket

because it was woven on an upright loom and its pattern exhibits Hispanic characteristics, should probably be assigned to the early 1860s. It is woven of indigo blue and natural white handspun wool, with two tiny touches of raveled cochineal-dyed red yarn. Raveled yarns are not typical of Rio Grande Spanish textiles. For further discussions of Navajo servants in Spanish households and of the problems of identifying slave blankets, see Kent (1983a:135–67), Stoller (1979:37–52), and Wheat (1976b, 1979:29–36).

Blankets and rugs woven entirely or almost entirely of commercial yarn in the late Transition period are spoken of as "Germantowns." Many are technically superior in weave, with small, delicate motifs precisely executed in fine, evenly battened wefts (plate 14). Germantown yarn, more regular in diameter than most handspun, lends itself to such exactitude. According to Rodee (1977:22), traders saved the expensive commercial wools for their more skillful weavers, which would further explain the generally high technical quality of Germantowns.

Germantown blankets and rugs usually have a cotton string warp, which is not infrequently discontinuous. Adjacent warps are a single length of string that has been doubled and looped through warp selvage cords at one warp edge of the blanket. The two ends of the string are knotted together at the other warp edge, and the knots are concealed by a heavy, multicolored yarn fringe fastened along the edge of the blanket (see fig. 58). The use of commercial yarns and warps was discouraged by traders, and by the turn of the century handspun yarns were once again the norm.

Many Navajo textiles dating from the Transition period are patterned by complex arrangements of serrated zigzag lines and other motifs worked in Germantown yarns or in handspun yarns brightly colored with the newly available aniline dyes. A wide variety of colors may be combined in a single blanket to create a startling visual effect. The more expert weavers often edged each design motif with a thin line of contrasting hue, adding to the number of colors they could introduce into a blanket. These bright, elaborately patterned textiles are termed, appropriately, "eye-dazzlers" (fig. 53).

Eye-dazzler patterns were not dictated by trader taste nor drawn from any foreign source, but are uniquely Navajo innovations devised to take advantage of a new range of colors not previously available. Brody (1976) calls the designs "enor-

Figure 52. The cochineal-dyed raveled reds in this serape make a date in the early 1860s a probability. Since it was woven on an upright Navajo loom and contains many lazy lines, but also has motifs suggestive of old Rio Grande blankets, it is designated a slave blanket. 81" x 49" (SAR T.189).

mously creative visual inventions." Concerning their origin he remarks:

> The Eye-Dazzler tradition was spontaneous and Reservation wide. Its practitioners included artists with every degree of skill, imagination and self confidence, who were market testing a new product on a new audience. Often they had only the barest idea of what the aesthetic expectations of that audience might be. However, use of Eye-Dazzler textiles as blankets by other Navajos at that time seems to indicate positive feedback by the Navajo people to the novel style.

The use of bright colors and the busy eye-dazzler patterns were discouraged by traders engaged in the rug business after 1900, although the design style and the trick of outlining motifs survived in (generally) more subdued colors in the Four Corners area among weavers around Teec Nos Pos and Red Mesa. Anglo-American acceptance of the eye-dazzler style is a recent phenomenon. Brody (1976) dates it to about 1970, and explains it as the result of a changing aesthetic among at least part of the buying public. In speaking of the rejection of the style by early rug dealers, he says: "The decision by traders and historians to ignore two decades of visual invention is understandable. They defined Eye-Dazzlers as repulsive aberrations that conformed to neither their aesthetic principles nor to those of the Navajo blanket weavers of an earlier generation."

Figure 53. The outlining of small serrated lines and the use of multiple colors combine to make a good example of a Germantown yarn eye-dazzler. Figures are in purple, red, green, yellow, and white on a red ground. 1885–1895, 48" x 33" (SAR T.516).

Another class of textiles, the pictorial blanket, also sprang into prominence in the Transition period, although a few blankets of the type were apparently woven in Classic times. The earliest surviving documented textile with a pictorial motif—four tiny ducks near its center—is the Chief White Antelope blanket (plate 2). Another pictorial blanket, with horses and a human figure, is said to have been collected in 1865, and one with floral motifs was mentioned by Kit Carson in 1840 (Wheat 1975:3).

The Transition period world of the Navajos was crammed with new phenomena, unfamiliar objects, and strange sights. It is perhaps no wonder that Navajo weavers, who had drawn design ideas from other cultures in the past, should see these fresh wonders too as apt subjects for their looms. The tapestry technique and the new range of aniline colors gave them the technology to reproduce whatever intrigued them—American flags, cattle, trains, letters, even labels from flour sacks or coffee cans (fig. 54; see also fig. 37). Although their subject matter has changed with time, pictorial blankets and rugs continue to be woven in the twentieth century (plate 15).

In addition to plain-weave tapestry blankets, Transition period Navajos produced a number of twill-woven articles. The most notable of these were double and single saddle blankets, the closely battened, sturdy fabrics of rather coarse handspun yarns that took the place of the sheepskin saddle pads used in the Classic period.

Figure 54. Probably woven in the 1880s, this soft, white handspun blanket has a charming pattern of black, tan, and olive green cows. 75" x 53" (SAR T.344).

Double saddle blankets are about thirty by sixty inches in size, and the two halves may be differently patterned. Single saddle blankets are about thirty inches square. Saddle blankets made between 1870 and 1890 often have tapestry-woven designs on solid-color twill backgrounds. Twill-weave textiles woven since 1900 more often exhibit self-patterns such as nested diamonds (fig. 55). The thick twill-weave saddle blankets made excellent small rugs, and they were purchased by Anglo-Americans for this purpose after 1900. Navajos still make twilled saddle blankets for their own use, and twills are used innovatively in contemporary rugs.

A saddle cinch is a broad band that is passed beneath a horse's belly, so that a saddle may be secured to it by straps. Cinches were woven on a set of warps fastened between two iron rings (fig. 56). Two such bands in the School of American Research collection are poorly executed twills with very coarse handspun wool warps and handspun or commercial yarn wefts; the third is a delicately patterned diamond-twill strap with fine handspun wefts (fig. 57). As it shows signs of having been used, it must have been serviceable in spite of its fine texture.

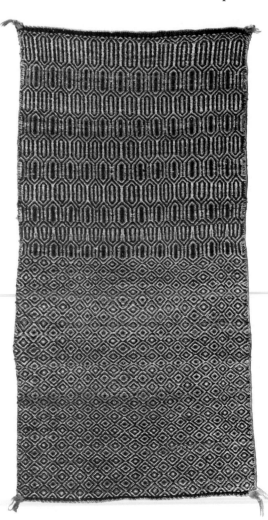

Figure 55. A double saddle blanket in four-thread diamond twill with white, red, and brown wefts, probably sold as a rug. 1920– 1940, 53½" x 27" (SAR T.537).

A saddle throw is any small decorative blanket that could be thrown over a saddle for comfort as well as show. Most were woven of Germantown yarns in plain-weave tapestry, and many had decorative fringing or long, elaborate corner tassels (fig. 58).

Two technical innovations of the Transition period are related to twill weave in that they require multiple heddles—at least four. The first of these, two-faced weave, is still practiced occasionally by a few very skillful weavers. The weave produces a blanket or rug with entirely different patterns on its two surfaces (plate 16). The work surface usually exhibits a complex tapestry design, and the underside a pattern of simple stripes. The weave is accomplished by using four heddles, two of which throw long floats of weft to the work surface, while the other two throw long floats to the back (fig. 59).

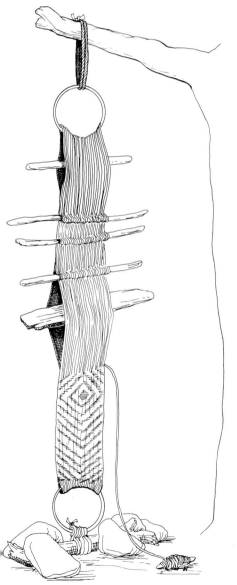

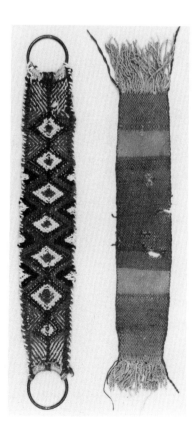

Figure 56. A partially woven diamond twill saddle cinch, the warps strung between two iron rings. (After Matthews 1884:Fig. 44.)

Figure 57. Two saddle cinches. The iron rings between which the warps were fastened are still in place on the cinch at left. Woven of coarse yarns in diamond twill tapestry, the piece probably dates between 1880 and 1900. 29" x 4½" (SAR 1981-15-4). The cinch at right is expertly woven of tightly retwisted four-ply white commercial yarn and fine handspun red yarn. 1875–1890, 21" x 4½" (SAR 1978-1-206).

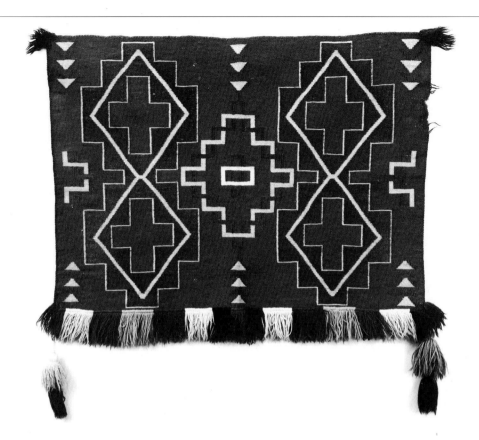

Figure 58. A Germantown yarn saddle throw with elaborate design in green, yellow, purple, and white on a red ground. 1885–1890, 25½" x 36" (SAR T.489).

The earliest documented two-faced weave dates to 1870, but the technique could not have been at all common at that time, as it was not recognized until the 1890s by either the trader Thomas Keam or Washington Matthews, army surgeon and ethnologist, both of whom were thoroughly familiar with Navajo weaving of the 1880s (Matthews 1900). The origin of the technique among the Navajos is something of a mystery since it has not been identified in either prehistoric or historic Pueblo textiles. However, it is familiar to Anglo-American handloom weavers and may have been taught to a Navajo woman by one of them. Alternatively, a Navajo weaver may have invented it or stumbled upon it in the course of experimentation with the warp combinations used in twilling. It has been suggested that Pendleton blankets, with their unmatched faces, could have furnished the inspiration for two-faced weave, but there is in fact no similarity in the way the two kinds of blankets are made.

Figure 59. a, The manner in which wefts are inserted for two-faced weave. The black and white wefts will show on the surface of the piece, the hatched wefts on the underside. *b*, The pattern of a black stripe flanked by white wefts on the surface of the piece. *c*, The unpatterned underside of the piece.

a

b

c

A second innovation was double cloth or double weave, which actually consists of two separate textiles back to back, joined at their edges and/or at regular or irregular intervals (fig. 60). If made on an upright loom, the two cloths would be woven simultaneously one behind the other. The technique may have been learned from Hispanic weavers, who practiced a form of double weave that enabled them to manufacture on their relatively narrow, horizontal looms two layers of cloth, one above the other, joined only at one edge. When removed from the loom, such a cloth opened out into a full-size blanket. In a Navajo example from the School of American Research collection (plate 17)—one of only two Navajo double cloths on record—wefts from one cloth seem to interlock at random with warps of the other, and the cloths are joined at both edges. The other known example, described by Amsden (1949:62–64), is a saddle blanket apparently woven in the 1880s.

Traders of the late Transition and early Rug periods customarily paid for ordinary blankets and rugs by the pound. A "pound blanket" is not distinguished by a particular type of design or weave, but is simply any piece woven of coarse handspun, aniline-dyed yarns. The practice of paying by weight obviously did little to encourage the careful cleaning and carding of wool or the spinning of fine yarn.

The Transition period of Navajo weaving ended in the closing years of the 1800s. Changes in the art since 1865 had been so dramatic that most blankets and rugs woven toward the end of the period bore little resemblance to textiles of Classic times. It should be recognized, however, that the innovations were, for the most part, initiated voluntarily by the weavers themselves as they made their own selection—albeit always with the market in mind—of the materials, dyes, and design ideas offered by Anglo-American culture. With the opening of the Rug period, foreign ideas began to affect these choices in a much more direct and compelling manner.

Figure 60. The way in which wefts are inserted in double weave. The white warps and wefts never interlock with the shaded warps and wefts.

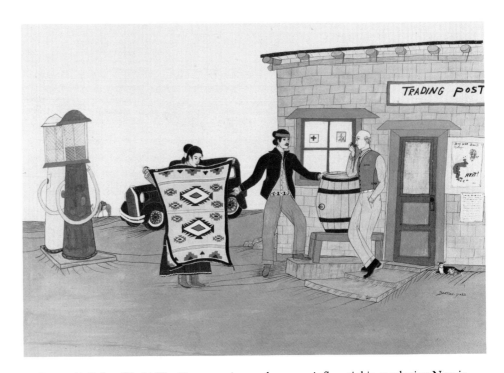

Figure 61. Before World War II, reservation traders were influential in marketing Navajo textiles, as well as in setting weaving styles. Beatien Yazz painted a familiar scene in the 1940s. (SAR 1983-12-148.)

Weaving Since 1895: The Rug Period

By the 1890s, the Navajos had virtually ceased to weave clothing and shoulder blankets. They still produced belts, ties, and saddle blankets for internal use, but most weavers were committed to the manufacture of rugs for sale to tourists. (Rugs are simply blankets woven from heavy, durable yarns and designed to withstand hard usage.) A number of factors had combined to make this shift inevitable: the loss of a national market for wool, the deterioration and depletion of Navajo sheep herds, the adoption of commercial-cloth and factory-produced clothing, the introduction of Pendleton blankets, and the phenomenal growth of tourism. This last, coupled with a burgeoning Anglo-American interest in the West, had created an expanding market for Indian handicrafts.

By introducing Navajo textiles in the form of rugs into this market, traders and dealers probably saved weaving from an untimely demise (fig. 61). In so doing, however, they inevitably imposed their own aesthetic, and that of Anglo-American buyers, on the weavers. Dealers turned against the use of Germantown yarn and cotton warp at the beginning of the Rug period, in part because it prevented them from advertising their wares as genuinely handmade. The preference for handspun was also part of an effort to restore some economic value to native wool. Their campaign was successful, and by 1900 most weavers had returned to the use of handspun yarns.

The traders disallowed certain colors, notably green, purple, and orange, and encouraged designs that proved acceptable to Anglo-American aesthetic preferences of the times. While they ensured the survival of the weaver's craft, however, such efforts did nothing to solve the problem of the increasing

inferiority of the wools with which most women worked, and this difficulty was not addressed until the twenties and thirties.

The first phase of the Rug period, from 1895 until after World War II, seems to me a time of directed change in textile design. Most rugs made in those years were marketed through reservation trading posts, and women weaving for a trader concerned with rug quality and design were so strongly influenced by his or her preferences as to develop a distinct style based on them.

One such regional style centered around Juan Lorenzo Hubbell's post at Ganado, Arizona. Hubbell favored Classic period textiles, examples of which are illustrated in a catalogue he issued probably in 1902. Although many of the pieces woven at Ganado in the early 1900s are quite faithful renditions of Classic period types such as two-piece dresses, mantas, chief blankets, and terrace-patterned serapes, they differ in materials. Since they are rugs, not blankets, they are made of relatively heavy wools. Both synthetic-dyed handspun and Germantown yarns appear in them, and some of these neo-Classic or "Hubbell revival" pieces even imitate Classic blankets in that they contain raveled reds in the form of synthetically dyed yarns raveled from American-made wool cloth (fig. 62). Hubbell favored a color combination of red with natural black, white, or grey yarns. The elements of a design that would have been indigo blue in Classic blankets are dark purple or black in his rugs.

Hubbell set high technical standards for his weavers, demanding regularity in design, evenly spun yarns, and straight selvages. He had rugs made to sizes specified by his customers, so that one sees Ganado pieces in the form of long, narrow hall runners or exceptionally large carpets that necessitated modifications in the looms on which they were woven. Hubbell's 1902 catalogue advertises "extra large native wool Navajo Blankets, for dining room and parlor use, tight weaves. Sizes from 8 x 9 to 12 x 12...$40.00 to $150.00." One outsize rug, woven at Ganado probably in 1895 and now in the collection of the Museum of Northern Arizona, is a two-faced weave measuring twelve by eighteen feet. The tradition of weaving large special-order rugs was carried on by Lorenzo Hubbell's

Figure 62. Probably woven at Hubbell's Trading Post in the 1890s, this rug has a red background of synthetic-dyed raveled yarn, and its indigo blue yarns are almost black in tone. The small hole at the center is called a Spider Woman hole; these appear on a few blankets and rugs, possibly as a symbolic escape route for the weaver's spirit. 80" x 56" (SAR T.108).

son Roman, who in 1937 commissioned what was until recently the largest Navajo rug ever made. It measured twenty-two by thirty-six feet and was woven by three women working in tandem over a period of three years (McNitt 1962:211–12). This rug is surpassed in size only by one woven for the Navajo Nation by ten women working on an oversized traditional loom at Chilchinbito in 1978 (Maxwell 1963:fig. 58).

Not all of Hubbell's designs are copies of Classic pieces, although they contain motifs largely drawn from Classic or early Transition period blankets. Hubbell exposed his weavers to the kinds of designs he preferred by putting up appropriate paintings on the walls of his trading post. These may be seen today in the rug room of Hubbell's Trading Post, now preserved as a historic monument and an active trading post by the National Park Service. Local weavers still consult the paintings for design ideas, and the present Ganado style is a continuation of that established by Hubbell before the First World War. Though more complex in detail, the basic modern design layout, like that of earlier times, is a large, bold central figure framed by a double border (plate 18; see also fig. 11). Nowadays the inner border may be quite intricate in pattern. The color scheme is still red, black, grey, and white. Both the black and red yarns are synthetically dyed, the latter being a distinctive dark, clear color popularly known as "Ganado red."

The influence of J. B. Moore, who owned the trading post at Crystal from 1897 to 1911, was considerably more revolutionary than Hubbell's. Moore turned for inspiration not to Classic period Navajo textiles but to rugs from Turkey and Iran, which were enjoying popularity among urban Americans at the time. He introduced his weavers to design layouts and motifs from these oriental rugs, adding such "Indian" elements as arrows. Swastikas figure prominently on Moore's rugs, as they do on Navajo rugs woven on other parts of the reservation in the early 1900s. The motif was so popular at that time that Herman Schweizer, buyer for the Fred Harvey Company, specifically requested that it be woven into the rugs he would purchase (McNitt 1962:235).

Known today as "early Crystals," the rugs produced under Moore's supervision were advertised in two illustrated mail order catalogues dated 1903 and 1911 (Rodee 1981:figs. 8–31; see also illustrations in G. W. James 1927). An informative article by Katina Simmons (1977) discusses and illustrates design similarities between Crystals and oriental rugs. The pattern layout of both consists of a large, elongated central figure, usually composed

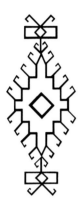

Figure 63. Motifs derived from oriental rugs or other Euro-American sources seen by Navajo weavers at the turn of the twentieth century. The hooklike elements extending from the edges of the figures are called latch hooks.

of two or three sections, placed vertically on the rug. Unlike the small, self-contained center figures taken by earlier Navajo weavers from Saltillo-type blankets, the center design on a Crystal is so large that it covers virtually the entire rug, its ends reaching almost to the borders, which are generally wide and elaborately figured. While Navajo weavers accepted this layout and certain eastern motifs, notably the "latch hook" (fig. 63), they did not make exact copies of oriental rugs but simplified the patterns, reproducing essential forms but deleting fine details and placing design elements in new configurations.

In speculating on Moore's design sources, Simmons suggests that he might have seen rugs with "airplane" motifs similar to one from Bergamo, Turkey, that Helen Hunt Jackson brought to Colorado Springs in 1873 (fig. 64). The "airplane" is reproduced on some early Crystals (fig. 65). Simmons points out also that by the turn of the century, illustrated books on oriental rugs had been published in this country, and industrially manufactured rugs and linoleum with oriental-like patterns were pictured in catalogues such as those of Montgomery Ward and Sears, Roebuck.

Crystal rugs were usually woven in aniline-dyed red combined with natural wool tones. Moore's wife supervised the careful dyeing of yarns handspun from native wool that had been sent East to be commercially scoured and carded. Rugs woven from this yarn by Moore's best weavers were sold as top grade (ER-20), priced from ninety cents to a dollar per square foot. Second- or tourist-grade rugs (T-XX) were woven from yarn cleaned, carded, spun, and dyed by the weavers themselves. These were priced at between one and two dollars a pound according to their quality. Moore never equated square feet with pounds, so it is difficult to say what the difference in price between a top-grade and tourist-grade rug of the same size actually was. However, the range of prices for his "T-XX" class rugs is given as ten to fifty dollars according to size and quality. He lists "ER-20" rugs for up to sixty dollars, so the latter were apparently more expensive. They could also be specially ordered in patterns and colors of the buyer's choice (Moore 1911:4–8).

Moore may not have been the only Anglo trader influenced by oriental designs. C. N. Cotton's 1896 catalogue illustrates a rug similar to some of Moore's, with a large center diamond figure outlined by hooks (Rodee 1981:fig. 4). Cotton, who had once worked with Hubbell at Ganado, had established a wholesale house in Gallup in 1894 supplying Navajo rugs to

eastern retailers. One of the designs he advertised may mark the genesis of what Rodee calls the "floating pattern," which consists of unusual geometric motifs, certainly not Navajo in origin, that seem to float on a solid-color ground (see fig. 28). This style has been maintained into the present in the Four Corners area and has been associated with Teec Nos Pos Trading Post since about 1940. "Floating" motifs in contemporary Teec Nos Pos rugs appear as though drawn with black lines on a gray ground, and filled in with tan or white (plate 19). Often they are outlined in bright colors or highlighted by the small spots of color that have earned them the name "jewel pattern" among collectors. Like most rugs woven in the Four Corners and Farmington areas since the 1940s, Teec Nos Pos rugs are generally made with commercial yarns.

The outlining of motifs is reminiscent of the eye-dazzler designs of the late 1800s and may have been maintained by weavers in the Four Corners region without a break. Or the practice may have been introduced among them by a Mrs. Wilson, a missionary who is said to have worked with weavers at Teec Nos Pos sometime before 1905 (McNitt 1962:343). Rugs

Figure 64. An oriental rug from Bergamo, Turkey, formerly owned by Helen Hunt Jackson. Late nineteenth century. (Courtesy Pioneers' Museum, Colorado Springs, Colorado.)

Figure 65. A page from J. B. Moore's 1911 catalogue. The pattern on the rug illustrated here was obviously inspired by one similar to that on the oriental rug shown in figure 64. (Collections of the Maxwell Museum of Anthropology; photo by Deborah Flynn.)

woven there in the early 1900s and nowadays at nearby Red Mesa often have patterns of outlined vertical zigzags, much like some eye-dazzlers (fig. 66).

The influence of many of the early traders continued to be apparent for several decades, and in some cases is still felt today. Although Moore left Crystal in 1911, for example, many of the design ideas he introduced were in evidence in the area until about 1940. Some were also utilized elsewhere on the reservation: thus Ganado rugs woven between 1920 and 1940 contain motifs first identified with Crystal, including latch hooks and compound center figures (Rodee 1981: figs. 49, 50).

The kinds of designs that developed at Two Grey Hills after World War I are clear derivatives of early Crystals. The style was well established by 1925 among weavers in the region around the Two Grey Hills Trading Post and the nearby post at Toadlena. The former was run by Ed Davies and the latter by George Bloomfield, both of whom had helped local weavers for a decade or more to improve the quality of their work. These rugs, which perpetuate many of the motifs as well as the pattern layout of early Crystals, were characterized by the exclusive use of natural wool colors: black, brown, beige, and white, with soft greys and tans made by carding dark and light fibers together. According to contemporary weavers near Ganado, the beige wool comes from a particular strain of animal which they call red sheep. Since the 1940s, the black color has been intensified by the use first of native and now of chemical dye.

Two Grey Hills designs are crowded arrangements of geometric motifs contained within double or multiple borders, the outer border solid black (fig. 67). A thin line of light-colored weft almost always runs from the design area through the borders to the outer edge of the rug near one of the upper corners. This is the "spirit trail" or "weaver's pathway," intended to ensure that the weaver's energies and mental resources will not be trapped within the encircling border but will follow the line out. "The moment of [weaving the] Pathway is a moment of liberation, of peace, of security. . .and a wish for the future: may the next weaving be even better" (N. Bennett 1974:35). The small hole found at the center of some blankets and rugs, called a Spider Woman hole, may have served the same purpose as the spirit trail.

Two Grey Hills rugs are among the most technically refined of modern weavings, having weft counts that average 90 and may be as high as 115 yarns to the inch. Most present-day pieces are woven from commercially washed and carded wool, finely spun, sometimes with the aid of a sewing machine.

Figure 66. Modern outline-style rug woven in the Four Corners area. An eye-dazzler pattern in gray, white, black, turquoise, red, orange, yellow, and brown. 1945, 78" x 49" (SAR T.462).

Figure 67. Woven by Daisy Tauglechee of Toadlena, New Mexico, in 1949, this handsome Two Grey Hills rug has a weft count of 96 to 110 yarns to the inch. It represents a full year's work. 67½" x 45" (SAR T.471).

Too soft for use as rugs, they are bought for wall hangings. Miniature Two Grey Hills rugs, incredibly fine in texture, are sometimes woven of thin single strands separated from plied commercial yarn.

One style illustrated in Moore's 1911 catalogue, the "storm pattern," has retained its popularity for decades (fig. 68). It has been associated with weaving in the western part of the reservation at least since the early 1920s (Hegemann 1963:302). The storm pattern is the only abstract Navajo design that is said to have symbolic meaning, but it is highly likely that this significance was attached to it by Anglo-Americans. The center box-like element is variously called the center of the world, a hogan, a lake, or the storm house; the smaller boxes at the four corners of the rug are either the houses of the wind or the four sacred mountains of the Navajos. These are connected to the center by zigzag lines representing lightning or the whirling logs seen in sandpaintings. Between these lines are small figures called water bugs or piñon beetles which resemble border motifs on oriental rugs. The whole design is enclosed by a single or double border. At the present time, storm patterns are woven in many colors and even in vegetal dyes, instead of the black, grey, white, and red scheme originally employed. There is some question as to whether the storm pattern was originated by Moore himself, by one of his weavers, or by a trader at Red Lake north of Tuba City, but we do know that Moore marketed such rugs.

A second type of Navajo blanket and rug popular among Anglo-Americans because of its symbolic content features representations of yei, yeibichai dancers, or sandpaintings. While not sacred in themselves and not used in Navajo rituals, such weavings do depict religious themes. Yei are the Holy People as represented in Navajo sandpaintings, or dry paintings. These are compositions that medicine men "paint" on the ground with colored sand and other dry materials in connection with curing ceremonies. The images must be destroyed the same day they are made. In spite of the intense feeling of many Navajos that representing dry paintings in permanent form was a dangerous and sacrilegious act, a few of these sacred compositions were woven into rugs, principally in the Chaco Canyon and Two Grey Hills regions,

Figure 68. A typical storm pattern rug, woven in black, red, and gray on a white ground. This is one of the Navajo rug designs copied in recent years on flat looms in Mexico. 1960s, 60" x 32" (SAR 1969-45).

in the late 1800s. This tradition has continued, and a few weavers in the Ganado area and elsewhere on the reservation produce dry-painting rugs today, working mostly from published sources (McGreevy 1982). Yeibichai are closely related stylistically to yei, but the rows of figures represent Navajo dancers in ceremonial attire rather than Holy People (Maxwell 1963:fig. 21).

It is perhaps inevitable that some weavers should have adopted yei figures from Navajo culture as subject matter, just as they had borrowed objects from Anglo-American culture. However, when religious elements were first incorporated into weaving, there was considerable opposition from many Navajos, and even today some weavers are uneasy at reproducing either dry paintings or yei figures (Rodee 1981:103–4).

A notable early producer of yei patterns was Yanapah, the Navajo wife of Richard Simpson, trader at Gallegos Trading Post near Farmington. From about 1900 until her death in 1912, she wove large single or paired yei into her rugs (Bailey and Bailey 1982:322; James 1927:figs. 200–202). A few weavers continued this style into the 1930s (fig. 69). The figures were woven vertically on the loom, whereas yei rugs and wall hangings made since the 1920s depict rows of smaller yei placed horizontally or at right angles to the warp.

There are two styles of yei, yeibichai, and sandpainting rugs, one centered in the Farmington-Shiprock area, and the other, which developed around 1930, near the trading posts of Lukachukai, Round Rock, and Upper Greasewood in northeastern Arizona. Shiprock-Farmington yeis generally have a light, often white, background and figures costumed in the bright colors of commercial yarn. Most of them lack borders (fig. 70). Lukachukai yeis are of handspun, synthetic-dyed yarn, usually rather coarse. The background is dark, and the figures are enclosed within a border (plate 20).

The medicine man Hosteen Klah, who lived near the trading post at Newcomb, began to weave his famous series of dry paintings in 1919 at the urging of the trader's wife, Franc Newcomb, both to ensure that his knowledge would be preserved in a lasting form and for financial gain (Newcomb 1964). With the assistance of his mother and his nieces, Mrs. Sam Manuelito and Mrs. Jim Manuelito, he produced perhaps as many as twenty-five large ceremonial rugs between 1919 and 1936, the year of his death (McGreevy 1982; Rodee 1977:93–110, 1981:101–4). One of these is illustrated in plate 21.

As discussed earlier, concerted efforts were made by private individuals

Plate 19. A contemporary Teec Nos Pos rug woven probably in the 1950s. Design motifs appear to have been "drawn" in fine white or black lines on the gray ground. One's eye is caught by the small, jewellike geometric motifs filled in with bright colors. 139" x 79" (SAR 1984-4-64).

Plate 20. The solid borders and dark background are typical of rugs with religious themes woven in the Lukachukai, Round Rock, and Upper Greasewood areas. The design on this rug is probably a linear sandpainting. About 1930, 88" x 50" (SAR T.704).

Plate 21. A Nightway sandpainting on a rug probably woven by Klah and Irene (Mrs. Jim) Manuelito, although the details of kilt and corn tassels resemble Gladys (Mrs. Sam) Manuelito's work. 1925–1930, 100" x 84" (SAR T.123).

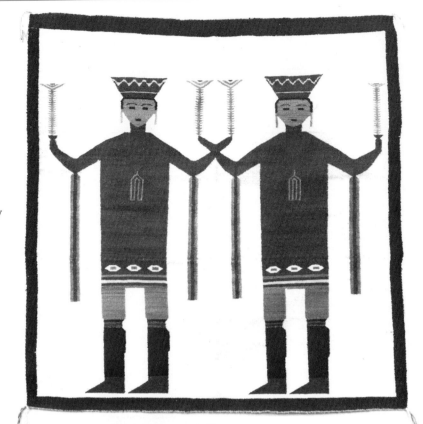

Figure 69. A rug with two large yeibichai figures placed vertically on the surface in the manner popularized by Yanapah. 1920–1930, 52" x 50½" (SAR T.114).

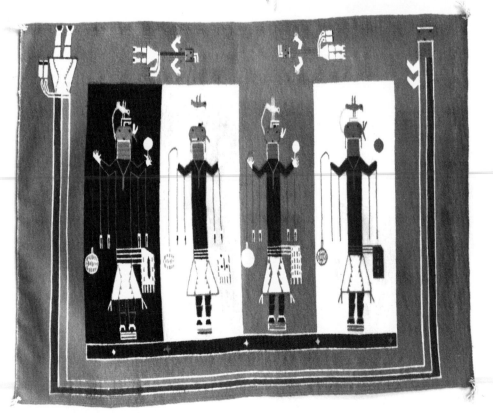

Figure 70. A contemporary sandpainting rug woven by Clara Nez in the Shiprock-Farmington style. 1982, 50½" x 40" (SAR 1983-14-5).

and government agencies to upgrade Navajo weaving in the twenties, thirties, and forties by improving the quality of yarns and dyes. Their work led to what has been called a revival, but might better be thought of as a revitalization, of the art. This resulted not in the actual copying of earlier types of textiles, but in the production of good-quality rugs featuring a range of improved commercial dyes and newly discovered vegetal dyes. The original thrust to improve dye quality was largely the work of Mary Cabot Wheelwright. In addition to her interest in dyes, Miss Wheelwright attempted in the 1920s to persuade weavers to turn to Navajo designs of the 1800s for inspiration instead of producing the oriental rug–derived patterns introduced by Moore, which she considered ugly. She did this by sending sketches of traditional blanket patterns to traders in the Chinle area for the weavers' edification. In the early 1930s, other members of the Eastern Association on Indian Affairs maintained this approach by distributing photographs of fine old blankets to schools, weavers, and traders in many parts of the reservation. Judging from the rugs subsequently woven at Chinle and other vegetal-dye centers, the designs selected by Miss Wheelwright and her collaborators must have been of the simple, borderless, banded style of the Transition period (fig. 71; Amsden 1949:223–235; I. Stoller 1977:453–66). Chinle rugs contain a few chemical dyes used in combination with the vegetal dyes, and black appears in some of the patterns. The quality of weaving is good, but not outstanding.

Several other regional styles of vegetal-dyed rugs evolved during this period of revitalization. In 1938 William and Sallie Wagner Lippincott, who had been rangers at Canyon de Chelly, bought the trading post at Wide Ruins and worked with weavers in the vicinity, eventually developing vegetal-dyed rugs with borderless, banded patterns. They encouraged technical excellence, and Wide Ruins rugs are still characterized by a fine, even weave and tightly spun yarns. Synthetic dyes are rarely used in them, nor is black; rather, they display a range of soft pastel shades, including pink (plate 23).

Pine Springs, not far from Wide Ruins, also became a center for production of revival-style vegetal-dyed rugs, as did Nazlini, south of Chinle. Rugs from Nazlini combine some bright synthetic colors with vegetal dyes as well as a pinkish color made from a crushed rock (Dutton 1961:29). Nazlini rugs are often patterned by plant forms representing corn stalks or cattails, which are placed within horizontal bands (fig. 72).

A distinctive type of vegetal-dyed rug has been produced in the

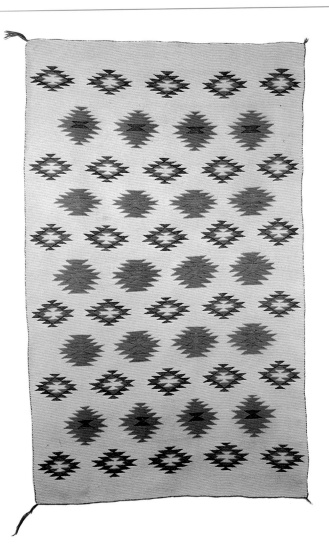

Plate 22. One of a limited number of Chinle-style rugs containing DuPont dyes. Obtained from Cozy McSparron in 1938. 75" x 45½" (SAR 1980-1-4).

Plate 23. A contemporary, vegetal-dyed Wide Ruins rug, one of a matching pair woven in the 1940s by Patsy Martin. 71½" x 37" (SAR 1980-1-2).

Plate 24. A Crystal rug woven by Alice Begay in the 1960s, showing the distinctive wavy-line pattern made by alternating two wefts of one color with two of another. 70" x 44½" (SAR T.729).

neighborhood of the old Crystal Trading Post since the 1940s (plate 24). Patterned by simple stripes in dark, rich browns and yellows, with the recent addition of some synthetically dyed yarns, it bears absolutely no resemblance to the early Crystal rugs sold by J. B. Moore. These modern Crystal-style rugs are noted for their characteristic "wavy line" pattern, in which undulating lines of color are produced by alternating wefts of two different colors, usually two picks of one color, then two picks of the second, and repeat. When the wefts are tightly battened, each stripe is wavy rather than straight edged (see fig. 40d).

Vegetal dyes are used in rugs from many other parts of the reservation at present; they may be found in storm patterns, twills, yeis, pictorials, or any other style of rug. Employing principally vegetal-dyed yarns, women in the Coal Mine Mesa area began in the 1960s to make rugs resembling traditional

Figure 71. A banded pattern in white, rust, gray, pale green and yellow, brown, and black, typical of rugs woven in the Chinle area. 1940, 64" x 42" (SAR T.350).

Figure 72. Typical Nazlini rug with plant motifs in red, yellow, brown, gray, black, and white. About 1950, 73" x 45" (SAR T.477).

double saddle blankets in pattern and size. Most are woven on four heddles, which are manipulated so as to produce handsome self-patterned textiles that may combine diamonds and other geometric shapes (fig. 73). One of the weavers' tricks is to use three colors of weft in repeated sequence in the four sheds established by the heddles (fig. 74), a device also used by saddle blanket weavers of the early 1900s to create all-over patterns of small nested diamonds or diagonal lines (see fig. 55; Hedlund 1983:184–85). A simultaneous development of twill weaving took place at Kinlichee, where some women today specialize in making rugs in which two-faced weave and twill are combined (Hedlund 1983:223).

A contemporary plain-weave rug type, visually related to these multiple-heddle weaves, also appears to be associated principally with the Coal Mine Mesa area. In it, a pattern of vertical lines of contrasting colors is produced

Figure 73. Sixteen heddles were required to produce the pattern in this twill weave rug woven by Mrs. Bare Bowman of Tohatchi, New Mexico, in 1942. 54½" x 35" (SAR T.396).

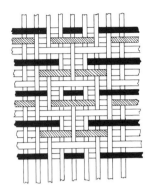

Figure 74. Four-thread diamond twill woven with three colors of weft repeated in sequence.

simply by inserting one color of weft in the first shed and another color in the second, and repeating this alternation throughout the pattern area (see fig. 40b).

Also associated with the 1960s revival of weaving at Coal Mine Mesa is the raised outline style, a plain-weave tapestry in which adjoining colors of weft yarns, at the point where they meet, float over two warps instead of the customary one. This produces a visually prominent join that appears to be raised above the surface of the textile (fig. 75; N. Bennett 1979:54–63). The earliest documented raised outline weave, now in the collection of the Museum of Northern Arizona, was made at Ganado in 1934 in natural grey and white yarns in combination with aniline-dyed red, black, and green (Kent 1981:18, 20).

The regional styles described above under the names Ganado, Crystal, Teec Nos Pos, Two Grey Hills, storm pattern (western reservation), Farmington and Lukachukai yeis, Chinle, Wide Ruins, and Coal Mine Mesa were clearly established by the early 1950s. They have been recognized and consistently defined by most writers on modern Navajo weaving and by contemporary weavers themselves, who may consciously set about reproducing a Two Grey Hills, a storm pattern, or whatever type meets their fancy (and is potentially remunerative). A number of other styles are described by one or another author but not universally accepted (see Hedlund 1983:215; H. L. James 1976).

Since 1980, a trader from southern Arizona has commissioned weavers from the Burntwater and Pine Springs–Wide Ruins areas, both vegetal-dye

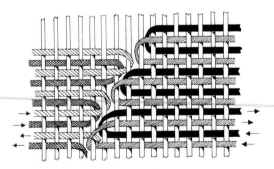

Figure 75. Detail of a raised outline rug woven by Desbah Begay of Coal Mine Mesa in the late 1960s. The vertical lines of color were produced by alternating two colors of weft: red and black in some parts of the weave, and gray and black, tan and white, and tan and brown in others. 61½" x 33". (SAR 1969-35; photo by Deborah Flynn.) The accompanying diagram shows the method of inserting wefts to create the raised outline effect.

centers, to dye wool to his specifications. He then delivers this yarn to expert weavers around the reservation whom he has weave rugs in the distinctive "Burntwater" style, which combines Two Grey Hills and Ganado motifs and design structure with the use of vegetal dyes (fig. 76). The regional name of Burntwater has been retained despite the fact that the weavers may come from Ganado, Two Grey Hills, or other far-flung districts.

While dealers, collectors, and traders are still instrumental in conveying the preferences of the buying public to "their" weavers, the women have much more control over their own product now than in the era of directed change. Roads on the reservation have been improved, and most weavers have auto transportation or are accessible to dealers, collectors, and tourists. They no longer must depend on a local trader as the sole buyer of their work but can choose the style of rug they wish to weave and market it wherever the best price is offered.

Certain highly imaginative and skilled individuals produce innovative designs by devising original color schemes and combining old motifs in new ways. If their work is recognized and awarded prizes in any of the various southwestern craft shows, shown in shops and galleries that feature Navajo weaving, or commissioned by a dealer or collector (as in the case of Burntwater rugs), it may become eminently collectible. Women whose work is so recognized become "name" artists with assured sales and the ability to draw high prices in the art market.

While most innovations nowadays are made by weavers themselves (albeit sometimes in consultation with an Anglo-American purchaser), the

Figure 76. A Burntwater rug (center) hangs in a gallery in Santa Fe, New Mexico, photographed in 1984. On the right are two rugs woven near Teec Nos Pos. (Photo by Deborah Flynn.)

introduction of totally new designs after the fashion of J. B. Moore does sometimes occur. For example, a 1983 exhibition in a Phoenix gallery featured Navajo weavings commissioned by a New York City firm and designed by the contemporary American painter Kenneth Noland. It remains to be seen, however, whether these alien designs will be incorporated into Navajo textiles as time goes on.

As in the past, approximately seventy-five percent of contemporary rugs are average-quality weavings displaying no distinctive regional or individual style. The repertoire, however, still includes various renditions of the standard regional styles, yei, yeibichai, and sandpainting rugs, pictorials, and so forth. Many women turn for inspiration to photographs of earlier weavings in catalogues, books, and magazines, and the rug designs on display at Hubbell's Trading Post are still consulted as a source. The copying of economically successful designs has been a conscious practice of Navajo weavers since the early Rug period (fig. 77).

The number of rugs produced annually has declined since World War II (Maxwell 1963:62–64). Many young women can find better ways of making a living than weaving for less than the minimum hourly wage. But in spite of the gloomy predictions of its demise by writers from Amsden in 1934 to Maxwell in 1963, the art is far from dead. Hedlund, writing in 1983 (p. 4), remarked that "at least for the moment weaving survives on the Navajo Reservation with vitality and purpose." Most Navajos value it as a distinctive

Figure 77. Successful rug designs developed at one trading post spread rapidly to weavers in other parts of the reservation. These sketches of Ganado and early Crystal rugs were made by a Navajo man living near Guam, New Mexico, in 1910, as patterns for his wife to copy. (McKinley County Criminal District Court Records, no. 98; courtesy New Mexico State Records Center and Archives.)

cultural attribute, and it is a proud family that numbers a competent weaver among its members. Even a modest skill in weaving allows a woman to supplement her family's income (Roessel 1983:595). The demand for Navajo rugs far exceeds the supply, which means that prices have escalated steadily over the last thirty years, strengthening the economic incentive for weaving. The introduction in the late 1970s of single-ply wool yarn chemically dyed in a range of colors closely approximating vegetal dyes has made it possible for women to bypass the tedious, time-consuming tasks of carding, spinning, and dyeing, and thus to increase their hourly monetary return (Bobb and Bobb 1983:87).

The long-term future of Navajo weaving still rests in a delicate balance. It is probably true that as long as the demand exists and weavers have no other means of supplementing their incomes, ordinary rugs will be woven. Quality rugs, however, take a long time to produce even if commercial yarns are used, and "for every five exceptional weavers that finally succumb to poor eyesight and arthritis, we are fortunate to find one younger weaver of any promise" (Bobb and Bobb 1983:90). Superior weavings, already dear, may become so rare as to be unavailable to all but the wealthiest collectors.

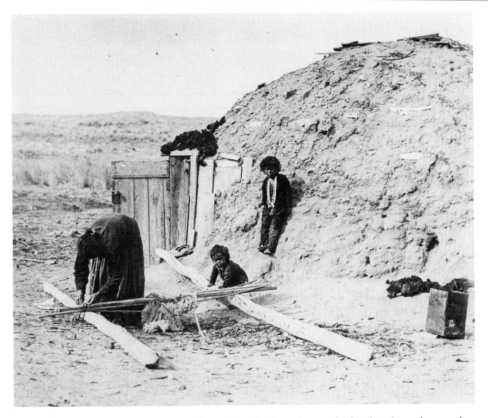

Figure 78. A Navajo woman completes the stringing of warps by binding loom bars and warping sticks together preparatory to fastening the warp in the upright loom. The scene illustrates the Navajo's informal approach of utilizing whatever comes to hand: the warping frame is simply two unworked poles. Bundles of black wool yarn lie on the ground and roof of the hogan. (Photo by Kenneth M. Chapman.)

The Search for a Navajo Aesthetic

VI

The dominant characteristic of Navajo weaving throughout its three centuries of existence has been the changing nature of its design—that is, its colors and patterns—which obviously reflects a succession of foreign influences. Influence, however, involves not only a donor but a recipient culture. Missing so far from our discussion is some explanation of how the Navajos reacted to novelty. Why were weavers so readily impressed by new ideas, and how did they handle them? How can loom products have changed so much and still remained recognizably Navajo?

Weaving may almost be regarded as a model of the dynamics of the Navajos' acculturation. Entering the Southwest as a simple hunting-gathering folk with very little cultural baggage, they selected what they could use from the Pueblo and Spanish civilizations, modifying the borrowed traits to fit their own needs and habits. Thus they managed to enrich their culture without jeopardizing their own identity. This opportunistic approach to life—the strategy of adopting whatever they could use—is surely one dynamic explaining the Navajos' ready acquisition of the new art of weaving and their subsequent flexibility in permitting stylistic changes.

The Navajos adjusted to their neighbors by trading, raiding, and, when pressed too hard, fleeing. They were not organized into a single sociopolitical unit but lived in small, autonomous, geographically isolated groups, with one band bearing no responsibility for the behavior of others. It is tempting to interpret physical isolation and social independence as the historical basis for the value the Navajos place even today on personal autonomy. Innovation in an art form must, in the last analysis, be made by an individual. This cultural

emphasis on freedom of choice can be seen as the second dynamic of change in Navajo design through the centuries.

Freedom in weaving was fostered by the fact that it was an art new to the Navajos, so that there were no cultural precedents controlling how or what they wove. The absence of traditional controls is the third dynamic of change in Navajo weaving. The effects of this lack of precedent become apparent when we compare the Navajos with the Pueblos, among whom weaving was an ancient art, formalized in both process and products. After the adoption of clothing made from commercial materials for daily wear, traditional loom-woven articles retained their symbolic significance as a way for the Pueblos to define themselves as a distinct cultural entity. In this context, traditional forms could not change significantly, but were maintained as ceremonial costumes.

Uninhibited by such ascribed meanings, the Navajos could accept the weaver's art on their own terms. It became a woman's skill rather than a man's since it fit the feminine role in Navajo society. Weavers adapted the loom to suit their own way of life and work habits (fig. 78). Instead of stringing warps between permanent upper and lower bars in an indoor work space, they wove wherever it was convenient to construct the loom. While weaving for the Pueblos was traditionally an art practiced by men isolated in kivas, among the Navajos it was a secular activity and a recognized part of a woman's daily routine. No firmly established rules governed the process. If it proved easier and quicker to weave one section of a fabric at a time, nothing prevented the weaver from doing so; if women found a two-piece dress more acceptable for daily wear than the traditional Pueblo manta-dress, nothing ruled out acceptance of the new style. Nor were there unwritten rules denying the addition of color or of decorative motifs to dress borders when some innovative weaver discovered the design potential in discontinuous wefts of contrasting colors. By the time Anglo-American clothing was adopted in the 1870s and 1880s, all that remained of Classic period traditional costume were the black dress and warp-patterned belt, retained for special occasions.

The Navajos produced Spanish-style serapes from the time they learned to weave, and there were no obvious controls on their design except what the weavers thought buyers might find attractive. This pragmatic approach has persisted to the present day, with modern weavers producing a variety of patterns and regional styles in accordance with Anglo tastes. Here we have the fourth dynamic of change in textile design, and the one that has been a

constant theme throughout this book: the demands of the market and the economic pressures underlying changes in style.

Navajo eclecticism in design is so pronounced that it masks any more subtle, culturally ingrained assumptions that might have guided the weavers in their choices of color and pattern structure. It is difficult to define a genuinely Navajo aesthetic in any but the most general terms. There do, however, seem to be some characteristics of style that dominate textile design through the Classic and Transition periods, or until the time when Navajos began to weave rugs for the Anglo trade rather than blankets for their own use. These characteristics include a balance in design, expressed in the alternation of dark and light stripes and in the ambiguity of figure and ground. Motifs are not placed on a background but are part of it. There is balance, too, between the elements of the total pattern on a blanket—between the upper and lower and the right and left halves. This balance often approaches bilateral symmetry (fig. 79), but exact symmetry is usually interrupted by slight irregularities in the pattern or by mismatched colors.

Variation in weft color appears to me to be the result of expediency, the weaver utilizing the materials at hand. The lack of precision in design probably reflects the way in which weavers worked, since they carried patterns in their heads, planning in advance how to fit them onto the warp but not transferring them to paper to serve as exact guides. Sometimes their mental images didn't quite fit the space and were modified as they wove.

Navajo design motifs are angular and tend to be large in scale, the pattern usually completely filling the blanket. Small, disconnected figures floating on the background are not characteristic of nineteenth-century Navajo design as they are of Saltillo. When small elements are used, they are generally organized into larger motifs or continuous lines. The typical pattern in Classic and Transitional blankets is not bounded by the four edges of the blanket but could theoretically be repeated ad infinitum beyond the sides and ends of the piece (of course, this particular characteristic does not hold for center-dominant designs of the Transition period).

There have been many interpretations of design as an

Figure 79. The Navajo feeling for bilateral symmetry, so marked in Classic and Transitional blankets, has persisted in the Rug period. It is clearly illustrated by the handling of the word STAR in this pictorial rug woven in the 1920s. 99" x 53" (SAR T.733).

expression of the Navajo personality. Kahlenberg and Berlant (1972:17), for example, regard "early first phase chief pattern blankets [as revealing] the essence of Navajo aesthetics with its paradoxical harmony and aggressiveness," and the second phase chief blanket as the epitome of "absolute balance and contained force" (1972:16). Most writers describe Classic period terraced patterns as bold, self-assured, and calm.

Hatcher (1974:179–80), in her study of Navajo design, writes of the Transition period serrate style, particularly as expressed in eye-dazzlers, as "characterized by...moderate complexity, great tension, and a considerable degree of freedom in composition. These qualities...interpretively clearly suggest very strong emotions and controlled aggression. They also convey a feeling of great vitality." Brody (1976) says of the same style, "It can be speculated but hardly proved that the visual intensity and spatial dislocation of Eye-Dazzlers were metaphorical and psychic responses to the dislocations and defeats of that period." His restraint is refreshing since it suggests that interpretations of design may be quite subjective, and that we tend to read into Navajo art what we believe the people must be like in light of their history.

Many anthropologists engaged in the cross-cultural study of personality in the forties and fifties applied the analytical techniques of European clinical psychology to the art of non-Western societies. Mills (1959) used the approach in his study of Navajo art, including weaving, but it is quite doubtful that in woven patterns formal elements of style such as vertical lines, angularity, outlining, balance, repetition, or color contrast have the psychological meanings he suggests, since so many of these characteristics are linked to the techniques and materials used by the artisan.

A discussion of meaning in Navajo textile design would be incomplete without some statement on symbolism. Reichard (1936:178) addressed the problem squarely when she wrote, "A question most frequently asked of those interested in the Navajo blanket is, 'But what does it *mean?*' There is something in our own way of thought, perhaps indefinable, which demands symbolism." Her answer to the question was, quite simply, "Nothing." She defined a symbol as "a design unit, or even an entire composition, which has a definite emotional content or meaning, immediately and spontaneously recognized by a group of people." Although many of the motifs found on blankets have descriptive names such as "crossed sticks" or "square within a square," there is no emotional content attached to them. This is not to say,

however, that there is no symbolism at the personal level: a weaver may ascribe a meaning to her pattern or to a feature such as the spirit trail or Spider Woman hole.

Reichard did not rule out symbolism in the religious art of sandpainting, where both color and motif have meaning or emotional content. But "the Navajo have kept the symbolic designs of their religion apart, in a separate compartment of their minds, from their ordinary blanket and silverwork patterns. The *form* occasionally overlaps; the emotions are kept distinct" (Reichard 1936:183). Thus certain symbols—such as the equal-armed (Roman) cross, which signifies the four directions, or the zigzag representing lightning—are charged with emotional content in sandpaintings but may appear in weaving quite simply as nice shapes. Weaving among the Navajos is a secular art, and the weaver is in conflict only when she reproduces for sale yei figures, which have religious content.

Color symbolism too, must be regarded as nonexistent in weaving. The artists at any given time in history used what was available to them. Judging from their increased use of red when they succeeded in obtaining commercial cloth for raveling and from the colors they chose when aniline dyes became available, they did prefer bright colors. This taste *may* reflect a culturally defined aesthetic—certainly their choices differed from those of their Hispanic neighbors.

The search for a distinctively Navajo aesthetic ends with the onset of the Rug period. When weavers ceased to manufacture blankets for their own use and turned to the production of rugs for sale to whites, they accepted Anglo-American standards of taste. Therefore we should not assume that a rug design style such as the storm pattern or Teec Nos Pos will tell us anything about Navajo personality or values. As Hatcher (1974:182) puts it, "The Teec Nos Pos looks like a Victorian idea of Indian design."

As we have seen, the rug styles that developed after 1895 reflect the differing tastes and values of influential traders, dealers, and ultimately buyers. All aspects of style were affected—color, motif, structure, and composition. Certain brilliant hues were outlawed. Some rugs utilized a whole new palette of soft, natural-vegetal-dye tones, negating the strong color contrasts that were so much a factor in the boldness of Transition-period blanket patterns.

What we saw as balance in blanket patterns has moved increasingly towards strict bilateral symmetry in contemporary rugs, and inexactness in

pattern and color are now considered flaws and ruled out in high-quality rugs. As Hatcher (1974:186) so aptly says, the most noticeable feature of commercial rugs

> is the exactness of the more recent pieces. Deviations from exact symmetry, variations in color are very rare. By all accounts, this is the result of pressure from the traders who sought to "improve standards." Esthetically, the effect is toward a lessening of vitality that is less pleasing than the effect produced by slight irregularities of the historic blanket styles. In terms of communication, this emphasis on perfection seems to convey the message that a human being is as good as a machine, which is comforting.

Symmetry and precision may also be the result of contemporary weaving practices. Many women now work from a draft or drawing, rather than a mental picture only.

Design styles from the Classic and Transition periods continue to be woven—stripes, terraced figures, and (at least in the Four Corners area) eye-dazzler serrate patterns—but a new concept, in the form of a solid, unfigured border completely enclosing the design field, profoundly changed the nature of much Navajo rug design after 1900. Amsden (1949:215–16) says regarding this development:

> This style is beyond much question a white man's imposition on the nascent rug business, since all our pictures are framed and all our rugs bordered. It is a mania with us: everything graphic must have a top, a bottom, two sides.....The significance of the border lies in the changed concept of the artistic problem. It creates an area of blank space to be filled, and in so doing suggests the use of isolated geometric figures. That of course is a new thing. The old patterns were not space-fillings, they were rather alternations of horizontal decorative zones, succeeding one another in regular order as far as space permitted.

Some scholars have interpreted bordered patterns as psychic projections of the reservation condition, visual reflections of life within boundaries. It seems to me that they are searching for a metaphorical response where none existed. Instead, it is much more likely that borders were accepted by weavers simply to meet Anglo-American stylistic conventions.

If we accept the premise that contemporary Navajo textile designs are not visual expressions of a cultural aesthetic but quite simply patterns woven to (unwritten) foreign specifications, then we would have to see the weavers not as creative artists but as skilled technicians, motivated solely by economic gain. That this is the dominant motivation for most weavers is undeniable; however, at least for the more talented women, there are other, compelling reasons for pursuing the art: "Income is not separate from enjoyment. After saying that the weaver's motive is primarily economic, Mrs. Francisco Mucho added, 'You get more fun out of it because that's what keeps you busy. Once you get interested in it, I don't know why it is, you just get the most fun out of weaving' " (Mills 1959:63).

Her statement and others like it made by and about Navajo weaving imply that it is the process of textile production that has cultural and personal meaning, not the design of the finished piece. The challenge is not to create a totally new design but to solve the technical and artistic problems involved in transferring one's personal version of standard motifs or a named style to one's own warp set. In this sense, Navajo weaving is a creative art. Weavers do undertake commissions to reproduce patterns that are not original with them, the motivation being, of course, economic (Hedlund 1983:203–5). However, "the weavers at Hubbell's, who make part of their living by producing copies from turn-of-the-century blanket drawings and from other *maquettes*, express relief when able to work from an original design, apparently because copying is boring—it lacks the excitement of creating your own design" (Hedlund 1983:208). At least one of the weavers Hedlund worked with "admits to enjoying 'just thinking' about all the possible combinations she can make, playing with the complicated patterns until she finds one that 'I want to see if I can do' " (1983:211). Mills's weavers reported that "they do not repeat designs, and look forward to experimenting with color and composition" (1959:65). While most compositions consist of recombinations of recognized Navajo motifs, occasionally a weaver will try something entirely new (fig. 80). Such innovations must be accepted as "Navajo" by the buying public if they are to enter the tribal design repertoire.

One contemporary weaver, Pearl Sunrise, sees an expression of Navajo values in the long series of time-consuming, physically demanding steps by which the wool of a sheep is combined with color, extracted perhaps from a number of local plants over the course of a year, to produce a totally new form. Lecturing at the University of Denver in May, 1983, she said that for

her, the custom of spinning at every odd moment exemplifies the Navajo ideal of keeping busy, while carding, spinning, and weaving itself express the value placed on patience and determination. It is important to work steadily at one's own rate and to keep at a task until it is finished. The Navajos believe that beauty lies within the individual, and in visualizing a pattern and then projecting it onto her loom, the weaver is expressing this beauty. Her designs will be judged good if they meet the Navajo ideals of harmony and balance.

Harmony in color and balance in design structure are consistently named by Navajo critics themselves as the most important aesthetic imperatives of textile design. In addition, Navajos judge the aesthetic value of a rug on the basis of the weaver's technical skills. Evaluating an art object in terms of the technical skill with which it was made, rather than as a personal expression, is a widespread practice in nonwestern societies. This is because technical skills are variable and can be objectively assessed and compared.

Figure 80. A floral-patterned Navajo pictorial rug woven in about 1949. Curves are not easy to weave in tapestry and are seldom attempted in Navajo work, but they have been mastered by a few innovative weavers. 68" x 50" (SAR T.472).

Those individuals whose work shows superior control of process will be recognized as artists and set apart from those of average skill (Sieber 1971:131).

Navajo eclecticism over three centuries produced many different styles, each of which has been defined in this book in terms of the designs, materials, and techniques that are generally consistent for it. As we have seen, the most significant changes have occurred in the realm of design, in part because of the use of new yarns and dyes and in part because of the introduction of foreign ideas. In principle, the door is open to unlimited further innovation if Navajo women so choose; new styles could arise at any time. The only control—and it is a powerful one—is acceptance of a style in the marketplace. It has to "look Navajo" to at least some members of the buying public. Fortunately for the survival of the art, there are as many different concepts of what that means as there are styles to choose from. For some, the epitome of Navajo weaving is the explosive strength of an eye-dazzler; for others, it is the quiet elegance of a well-woven vegetal-dye rug. Many prefer yei or storm pattern rugs, which are seen as laden with symbolic meaning, and others like the technical perfection and involved patterning of a Two Grey Hills. There is, in fact, something for everyone in Navajo weaving.

If there is no single set of aesthetic principles underlying the designs of the Classic, Transition, and Rug periods, and if new materials have changed the texture and color of Navajo blankets and rugs over the centuries and continue to do so, then how exactly are we to define a "Navajo textile"? As in the case of other traditional crafts, the common thread that ties the old and new together is technique: a Navajo textile is one that has been woven by a Navajo using traditional processes and tools. This much must remain constant whatever changes in style and materials take place as the years go on.

Appendix:
The School of American Research Collection of Navajo Textiles

The School of American Research collection of some four hundred Navajo textiles, though not the largest in the country, is a well-balanced one in the variety of historical types it contains, and it is a valuable research resource. It was begun in the 1920s under the discriminating eye of the late Dr. Harry P. Mera, and many of the School's pieces have been illustrated as type specimens by him and other students (Mera 1947, 1949; Amsden 1949; Berlant and Kahlenberg 1977). Although the bulk of the collection is not exceptionally well documented, the histories of a few articles are unusually complete: the Chief White Antelope blanket (plate 2); the pieces collected by General Chambers McKibbin; the contemporary rugs from Wide Ruins donated by Sallie R. Wagner; and the Two Grey Hills rugs from the McCune collection. Among the collection's strengths is a group of eight (and perhaps as many as thirteen) "slave" blankets, Navajo woven but showing strong Hispanic influence (Kent 1983a). Another asset is ten women's shoulder blankets with tapestry-patterned borders ("fancy" mantas), a type previously attributed to the Pueblo Indians. The Classic and early Transition period children's wearing blankets are of outstanding quality and charm and are particularly valuable to researchers for the mix of materials and patterns they contain.

The following list gives basic information about each Navajo textile in the School of American Research collection. They are listed in sixteen categories that are either explicitly or implicitly followed in the text and that are ordinarily employed in the literature on Navajo weaving. It is not always

easy to determine which category a textile fits into. Sometimes the decision to call a blanket late Classic rather than early Transition, or late Transition rather than early Rug, is simply an educated guess. In this catalogue, a piece is designated Germantown if the bulk of materials in it are commercial four-ply yarns. This means that if the background yarns are handspun and the design yarns commercial, the blanket is not considered a Germantown. For some textiles a choice had to be made between several categories. For example, specimen T.588, listed as a Germantown blanket, could also be called a Hubbell revival or a Moqui-pattern piece.

Textiles that are illustrated in this book are marked with an asterisk, and full information about yarns, dyes, and significant technical features is given. Measurements are recorded in inches and centimeters, with the length as measured along the warps always given first. The yarn count, or number of warps and wefts per inch (2.5 cm), is given as, for example, "warps: 10," or "wefts: 15."

Direction of spin, number of plies in a yarn, and direction of final twist in a multiple-ply yarn are recorded as follows (see also fig. 23):

z or s	single-ply z-spun or s-spun yarn;
Z or S	direction of final twist of a multiple-ply yarn; when used alone, indicates that the number of plies and direction of spin for each ply have not been determined; if the number of plies is known, the notation may read 3S, 2Z, and so forth;
z-S	z-spun, S-twist, two-ply yarn; comparable notations are z-Z, s-Z, and s-S;
3z-S	z-spun, S-twist, three-ply yarn; comparable notations are 4z-S, 3s-Z, and so forth.

In referring to dyes in the following list, "natural" means that the yarn was not dyed, while "vegetal" indicates that a vegetal dye was presumably used, although the yarns have not been tested. Aniline or other commercial, synthetic dyes are denoted as "synthetic." All reds specified as lac or cochineal have been tested and confirmed by Dr. David Wenger.

Those interested in obtaining more information about the School of American Research collection of Navajo textiles should write to the Director, Indian Arts Research Center, School of American Research, Post Office Box 2188, Santa Fe, New Mexico 87504.

WOMEN'S SHOULDER BLANKETS (MANTAS)

*T.4 (p. 55) Striped pattern, 1875–1880, purchased from Frank C. Applegate, 1927. 46" x 62" (117 x 157 cm). Warps: 8; handspun wool, z, natural white. Wefts, 44; handspun wool, z, natural brown and carded gray, vegetal indigo blue and green, and synthetic red. Selvages: warp and weft, 2 3z-S gray handspun wool yarns. Corners: selvage yarns worked back through fabric and knotted to make tassels.

*T.7 (p. 61) Fancy manta, 1870–1880, gift of Mary Cabot Wheelwright, 1927, from the collection of Major General A. E. Bates. 38" x 56" (96 x 142 cm). Warps: 21; handspun wool, z, natural brown. Wefts: 68; handspun wool, z, natural brown and vegetal indigo blue; raveled commercial wool, s, tripled, not twisted, synthetic(?) orange-red and synthetic(?) dark red; commercial wool, 3z-S, synthetic(?) pale green. Selvages: warp and weft, 3 3z-S indigo blue handspun wool yarns. Corners: selvage yarns knotted, extra indigo blue yarns inserted to make tassels.

T.310 Striped, Phase II pattern, 1860–1875, purchased from Fred Harvey Co., 1936.

T.322 Striped, Phase III pattern, 1870–1880, purchased from Raymond Stamm, 1938.

T.354 "Blue borders," late 1800s, gift of Victor Higgins, 1941.

*T.355 (p. 43) Fancy manta, 1870–1880, purchased from Fred Harvey Co., 1941. 40" x 61" (102 x 155 cm). Warps: 19; commercial cotton string, 4z-S, natural white. Wefts: 28; handspun wool, z, vegetal indigo blue and synthetic orange-red; raveled commercial wool, tripled, z, synthetic(?) red. Selvages: warp, 2 strands, each containing 4 4-ply red commercial wool yarns; weft, 2 3z-S handspun red wool yarns. Corners: selvage yarns knotted, extra handspun red yarns inserted to make tassels.

*T.358 (p. 68) "Maiden shawl," 1900–1930, purchased from H. P. Mera, 1941. 35" x 42" (89 x 107 cm). Warps: 6; handspun wool, z, natural white. Wefts: 20; handspun wool, z, natural white and brown and synthetic red. Selvages: warp and weft, 2 3z-S handspun brown wool yarns. Corners: extra brown and white yarns added; one tassel missing, one is made by knotting brown yarns together, two are brown and white braids.

T.359 Fancy manta, 1880–1890, purchased from H. P. Mera, 1941.

T.360 Fancy manta, 1875–1885, purchased from H. P. Mera, 1941.

*T.361 (p. 56) Striped, Phase III–IV pattern, 1870–1885, purchased from H. P. Mera, 1941. 52" x 56" (133 x 142 cm). Warps: 9; handspun wool, z, natural brown. Wefts: 51; handspun wool, z, natural brown, white, and carded gray, and vegetal green and indigo blue; raveled commercial wool, s, single or paired, synthetic red; commercial wool, 3z-S, synthetic red. Selvages: warp, 2 3z-S handspun light blue wool yarns; weft, 2 2z-S handspun light green wool yarns. Corners: extra indigo blue handspun yarns inserted to make tassels, but selvage yarns are largely missing.

T.362 Striped pattern, 1875–1885, purchased from H. P. Mera, 1941, originally in the C. N. Cotton collection.

T.369 Striped pattern, 1870–1880, purchased from H. P. Mera, 1941.

T.370 Striped, Phase II pattern, 1870–1880, purchased from Fred Harvey Co., 1941.

T.388 Fancy manta, 1890–1900, purchased from Ina Sizer Cassidy, 1942.

T.420 Striped, Phase III pattern, 1860–1875, purchased from Bessie S. McKibbin, 1944; originally in the Gen. Chambers McKibbin Collection, 1880.

T.423 Fancy manta, 1870–1880, gift of Mrs. Frank Applegate, 1944.

T.513 1870–1875, gift of Amelia E. White, 1954. Solid-color background, 3 design bands as in chief pattern.

T.536 Fancy manta, 1880–1895, gift of Amelia E. White, 1954.

T.585 Fancy manta, 1865–1875, gift of Margretta S. Dietrich, 1961.

T.611 Striped, Phase II pattern, 1860–1870, gift of Amelia E. White, 1963.

T.612 Striped, Phase IV pattern, 1875–1885, gift of Amelia E. White, 1952.

T.613 Striped, Phase IV pattern, 1890–1900, gift of Amelia E. White, 1952.

T.636 Striped, Phase II–III pattern, 1875–1880, gift of Amelia E. White, 1953.

T.698 Fancy manta, 1875–1880, gift of Mrs. George A. Paloheimo, 1964.

***T.707** (p. 57) "Blue borders," late 1800s, gift of Mr. and Mrs. Nathaniel A. Owings, 1964. 43" x 50½" (109 x 128 cm). Warps: 15; handspun wool, z, natural brown. Wefts: 30; handspun wool, z, natural brown in diagonal twill and vegetal indigo blue in diamond twill. Selvages: warp, 2 3z-S brown handspun wool yarns; weft, 2 2z-S brown handspun wool yarns. Corners: worn, but it appears the warp and weft selvage yarns were knotted separately.

WOMEN'S TWO-PIECE DRESSES

***T.25** (p. 9) One-half only. 1860–1870, purchased from Clara E. Brentlinger, 1927. 56" x 36" (142 x 91 cm). Warps: 12; handspun wool, z, natural white. Wefts: 60–68; handspun wool, z, natural black and vegetal indigo blue; raveled commercial wool, s, paired, probably lac and cochineal red. Selvages: warp and weft, 3 3z-S indigo blue handspun wool yarns. Corners: selvage yarns knotted, extra blue yarns inserted to make tassels.

T.60 1860–1870, purchased from H. P. Mera, 1930.

***T.69** (p. 43) One-half only. 1850–1860, purchased from N. Howard Thorpe, 1929. 52" x 30" (132 x 76 cm). Warps: 16; handspun wool, z, natural white stained pink. Wefts: 66–78; handspun wool, z, natural brown/black and vegetal dark indigo blue; raveled commercial wool, s, paired, in lac and cochineal raspberry red. Selvages: warp and weft, 3 2z-S indigo blue handspun yarns. Corners: selvage yarns tightly tied so corners roll in, extra blue yarns (largely missing) inserted to make tassels.

***T.372** (p. 61) 1860–1870, purchased from Frank Patania, 1941. Each piece 50" x 34½" (127 x 88 cm). Warps: 14; handspun wool, z, natural white. Wefts: 64; handspun wool, z, natural brown, vegetal indigo blue, and synthetic green; raveled commercial wool, s, paired or tripled, in lac and cochineal red. Selvages: warp and weft, 2 3-ply indigo blue handspun wool yarns; weft, sides partially sewn together with 2z-S red yarns, probably raveled and respun. Corners: selvage yarns knotted, extra yarns inserted to make tassels.

T.386 1860–1870, purchased from Mrs. Judson R. Grant, 1942.

T.435 1890–1900, gift of Amelia E. White, 1945.

T.487 1870–1875, purchased from Mrs. C. W. Kemp, 1952.

T.506 1890–1900, gift of Amelia E. White, 1954.

T.594 1860–1870, purchased from Ina Sizer Cassidy, 1961, originally purchased at Hubbell's Trading Post in 1912.

T.631 1890–1900 or later, gift of Amelia E. White, 1953.

T.632 1870–1875, gift of Amelia E. White, 1953.

T.633 1870–1875, gift of Amelia E. White, 1953.

T.634 1860–1870, gift of Amelia E. White, 1953.

MEN'S SHOULDER BLANKETS (CHIEF BLANKETS) AND RUGS WITH SIMILAR PATTERNS

T.2 Phase III–IV pattern, 1890–1900, gift of Amelia E. White, 1927.

***T.46** (p. 54) Phase II pattern, 1850–1860, gift of Mary Cabot Wheelwright, 1928. 58" x 76" (147 x 193 cm). Warps: 10; handspun wool, z, natural white. Wefts: 63; handspun wool, z, natural white and brownish black; raveled wool, z, paired, presynthetic red. Selvages: warp and weft, 2 3z-S indigo blue handspun wool yarns. Corners: extra blue yarn inserted to make tassels.

T.62 Phase III pattern, 1865–1875, purchased from Caroline Sheridan Baker, 1929.

T.71 Phase II pattern, 1860–1870, purchased from V. J. Holmes, 1930.

***T.304** (p. 52) Phase I pattern, 1800–1850, gift of George N. Bloom, 1928. 60" x 69" (152 x 175 cm). Warps: 14; handspun wool, z, natural white. Wefts: approx. 80; handspun wool, natural brownish-black and white and vegetal indigo blue. Selvages: warp and weft, 2 3z-S indigo blue wool yarns. Corners: extra blue yarns inserted to make tassels.

***T.328** (p. 54) Phase III pattern, 1860–1870, purchased from J. S. Burns, 1938. 58" x 76" (147 x 193 cm). Warps: 10; commercial wool, 3S, natural white. Wefts: 61; handspun wool, z, natural white and brownish black; raveled wool, z, paired, presynthetic(?) red. Selvages: warp and weft, 2 3z-S indigo blue handspun wool yarns. Corners: extra blue yarns inserted to make tassels.

T.349 Phase III pattern, 1865–1875, purchased from Mrs. J. W. Chatterton, 1941.

T.352 Phase II pattern, 1850–1865, purchased from Mrs. Sam Hamilton, 1941.

T.365 Phase II pattern, 1860–1870, purchased from H. P. Mera, 1941.

T.428 Phase IV pattern, woven as a rug, 1900, gift of Kenneth M. Chapman, 1944.

T.433 Phase II pattern, 1860–1870, gift of Amelia E. White, 1945.

T.469 Phase III pattern, 1870–1885, purchased from Mrs. L. Heartwell, 1948; originally purchased at the Hopi House, Grand Canyon, 1905.

T.568 Phase IV pattern, probably woven as a rug, early 1900s, gift of Margretta S. Dietrich, 1961.

T.610 Phase III pattern, 1865–1875, gift of Amelia E. White, 1952.

T.635 Phase III–IV pattern, 1880–1890, gift of Amelia E. White, 1953.

T.637 Phase IV pattern, 1875–1890, gift of Amelia E. White, 1953.

T.658 Phase III pattern, woven as a rug, 1885–1900, gift of Elizabeth Derr Davisson, 1962.

T.682 Phase IV pattern, woven as a rug, 1890–1900, gift of Mrs. Chandler Hale, 1962.

***1981-8-3** (p. 53) Phase IV pattern, woven as a rug, 1890–1900, gift of Mr. and Mrs. Alden B. Hayes. 59" x 81" (150 x 206 cm). Warps: 5; handspun wool, z, natural white. Wefts: 19; handspun wool, z, natural white and brown, and synthetic purple-black, red, yellow, and green. Selvages and corners: restored.

1983-23-2 Phase III pattern, woven as a rug, 1920–1930, gift of Fred Patton, 1983.

1984-4-59 Phase III pattern, 1880–1890, given in memory of Margaret Moses, 1984.

BELTS

T.592 1915, purchased from Ina Sizer Cassidy, 1961; originally purchased at Hubbell's Trading Post, 1915.

T.655 1960, purchased by anonymous donor at Hubbell's Trading Post, 1961.

T.686 1938, gift of Dorothy Morang, 1963.

***1979-6-74** (p. 32) 1910–1930, gift of Mabel Morrow, 1979. 118" including fringe x 4½" (300 x 12 cm). Warps: (edges) 41, commercial wool, 4z-S, synthetic red

and green, and commercial cotton string, 4S, natural white; (center) 44, commercial wool, 4z-S, synthetic red, and commercial cotton string, 4S, natural white. Wefts: 10; commercial cotton string, 4S, natural white.

CLASSIC PERIOD BLANKETS (SERAPES)

***T.8** (p. 48) 1850–1860, gift of Mary Cabot Wheelwright, 1927, originally in the collection of Major General A. E. Bates. 65" x 51" (165 x 130 cm). Warps: 12; handspun wool, z, natural white. Wefts: 74; handspun wool, z, natural white and vegetal indigo blue; raveled commercial wool, s, paired, lac red. Selvages: warp and weft, 2 3z-S indigo blue handspun wool yarns. Corners: selvage yarns knotted, extra blue yarns inserted to make tassels.

T.34 1860–1870, gift of Mary Cabot Wheelwright, 1928.

***T.43** (p. 39) 1860, purchased from Fannie Clark Wigginton, 1929; originally taken from the body of Chief White Antelope after the Sand Creek Massacre, 1864. 76" x 56" (193 x 142 cm). Warps: 12; commercial cotton, 3S, natural white; commercial cotton, 2S, 1 ply natural white, 1 ply natural(?) brown. Wefts: 89; commercial silk, 3Z, natural white; commercial wool, 3Z, vegetal indigo blue; commercial wool, very fine, 3Z, synthetic lavender, orchid, yellow, red, black, peach, tan, green, and pink; handspun wool (at one end), z, natural white. Selvages: warp and weft, 2 strands, each containing 3 3Z commercial green yarns. Corners: worn.

***T.175** (p. 37) 1860–1865, gift of Amelia E. White, 1931; originally purchased in Santa Fe, 1860s or 1870s. 81" x 58" (206 x 147 cm). Warps: 16; commercial cotton string, 3S, natural white. Wefts: 86; commercial wool, 3z-S, natural white and synthetic(?) olive green, gray green, pink, red, indigo blue, and pale blue. Selvages: warp and weft, 2 3-strand yarns, each strand a commercial 3z-S white yarn. Corners: missing.

***T.375** (p. 38) 1850–1860, purchased from Captain Johnson, 1941, originally obtained at Fort Wingate in the 1880s. 79" x 53" (201 x 135 cm). Warps: 13; handspun wool, z, natural white. Wefts: 65; handspun wool, z, natural white and vegetal indigo blue and green; raveled commercial wool, s, single or paired, lac and cochineal red. Selvages: warp, 3 2z-S handspun indigo blue wool yarns; weft, 2 2z-S handspun indigo blue

wool yarns. Corners: selvage yarns may have been knotted, extra commercial pinkish red yarns inserted to make tassels.

T.667 1860–1870, gift of Mrs. Chandler Hale, 1962.

TRANSITION PERIOD BLANKETS (SERAPES) AND RUGS

T.3 Rug? 1890–1900, gift of Mary Cabot Wheelwright, 1926.

T.5 1880, purchased from Spanish and Indian Trading Co., 1927.

T.14 1870–1875, purchased from Andrew Dasburg, 1927.

T.26 1890, purchased from Mary E. Dissette, 1929.

T.35 1870–1880, purchased from E. C. McMechen, 1928.

T.36 1870–1880, purchased from the Denver Art Museum, 1928.

T.48 1880–1890, gift of Raymond Otis, 1929.

T.49 1880, exchange from the Denver Art Museum, 1929.

T.50 1870–1880, exchange from the Denver Art Museum, 1929.

T.51 1880, exchange from the Denver Art Museum, 1929.

T.55 1880, gift of Amelia E. White, 1929.

T.61 1880–1885, purchased from H. P. Mera, 1930.

T.70 1870–1880, purchased from Spanish and Indian Trading Co., 1930.

T.72 Rug, 1890, purchased from A. Edgcomb, 1930.

T.74 1880–1890, gift of Corina L. Smith, 1930.

T.75 Rug, 1890–1900, purchased from John B. Graves, 1930.

T.76 1865–1875, purchased from John B. Graves, 1929.

T.78 1880–1890, purchased from E. C. McMechen, 1930.

T.79 1880–1890, purchased from V. J. Holmes, 1930.

T.80 1880–1890, purchased from V. J. Holmes, 1930.

T.82 1865–1875, purchased from Ernest Alarid, 1929.

T.102 1875–1885, gift of Dorothea Moore, 1930, once owned by Charles F. Lummis.

T.105 1880–1890, purchased from Fred Harvey Indian Dept., 1930.

T.106 About 1875, purchased from Fred Harvey Indian Dept., 1930.

T.110 1870–1880, purchased from Fred Harvey Indian Dept., 1930.

T.111 1870–1880, purchased from Fred Harvey Indian Dept., 1930.

T.120 1880–1890, gift of Amelia E. White, 1930.

T.124 1865–1875(?), gift of Mary Cabot Wheelwright, 1930.

T.127 1880–1890, gift of Frank C. Applegate, 1930.

T.171 1875–1885, purchased from Silviano Salazar, 1931.

T.172 1880–1890, purchased from E. L. Griego, 1931.

T.191 1870–1875, purchased from E. S. Toelle, 1931.

T.192 Rug, 1885–1900, purchased 1931.

T.193 1870, purchased from Old Santa Fe Trading Post, 1931; originally purchased in Taos, 1890.

T.195 1880, purchased from E. L. Griego, 1932.

T.199 1880–1890, purchased from Kenneth Miller, 1932.

T.203 1880–1890, gift of Elmer Shupe, 1932.

T.307 1890, gift of H. P. Mera, 1935; originally purchased in 1903.

T.314 1865–1870, gift of Mrs. Samuel Cabot and Mrs. Henry Lyman, 1936.

T.316 1890, gift of H. P. Mera, 1936; originally purchased from Abe Spiegelburg in 1906.

T.317 1890, gift of H. P. Mera, 1936; originally purchased in 1906.

T.334 1875–1880, purchased from Mrs. Ingalls Davis, 1940, originally owned by Senator Ingalls of Kansas.

T.339 1880–1890(?), purchased from Pasquel Montoya, 1940.

T.351 1870–1880, purchased from Frank Packard, 1941.

T.368 1880–1890, purchased from H. P. Mera, 1941.

T.377 1880–1890, gift of Mary Cabot Wheelwright, 1942.

T.378 1880–1890, gift of Mary Cabot Wheelwright, 1942.

T.379 1880–1890, gift of Mary Cabot Wheelwright, 1942.

T.399 Rug, 1890, purchased from AWVS War Bond Exchange, 1943.

T.408 1880–1890, gift of Mrs. James R. Thorpe, 1944.

T.410 1870–1880, purchased from Bessie S. McKibbin, 1944 (Gen. McKibbin collection).

T.411 1875–1880, purchased from Bessie S. McKibbin, 1944 (Gen. McKibbin collection).

T.412 1875–1880, purchased from Bessie S. McKibbin, 1941 (Gen. McKibbin collection).

T.413 1870–1880, purchased from Bessie S. McKibbin, 1944 (Gen. McKibbin collection).

T.416 1870–1880, purchased from Bessie S. McKibbin, 1944 (Gen. McKibbin collection).

T.417 1870–1880, purchased from Bessie S. McKibbin, 1944 (Gen. McKibbin collection).

T.418 1870–1880, purchased from Bessie S. McKibbin, 1944 (Gen. McKibbin collection).

T.419 1880, purchased from Bessie S. McKibbin, 1944 (Gen. McKibbin collection).

T.429 1865–1875, purchased from Bessie S. McKibbin, 1944 (Gen. McKibbin collection).

T.430 1875–1880, purchased from Bessie S. McKibbin, 1944 (Gen. McKibbin collection).

T.463 1880, purchased from Laura Gilpin, 1945.

T.466 1870–1880, purchased from Mrs. G. Fred Hawkins, 1946.

T.511 1880–1890, gift of Amelia E. White, 1961.

T.517 1870–1880, gift of Amelia E. White, 1954.

T.520 1875–1885, gift of Amelia E. White, 1954.

T.521 1880–1890, gift of Amelia E. White, 1961.

T.522 1875–1885, gift of Amelia E. White, 1961.

T.524 1880–1890, gift of Amelia E. White, 1961.

T.525 1880–1890, gift of Amelia E. White, 1961.

T.526 1870–1880, gift of Amelia E. White, 1954.

T.527 1870–1880, gift of Amelia E. White, 1954.

T.529 1880–1890, Gift of Amelia E. White, 1961.

T.530 1865–1875, gift of Amelia E. White, 1954.

*T.531 (p. 55) 1865–1875, gift of Amelia E. White, 1954. 52" x 33" (132 x 84 cm). Warps: 14; commercial wool, 3S, natural white. Wefts: 86; handspun wool, z, natural white and vegetal indigo blue; raveled commercial wool, z, paired, synthetic green; raveled commercial wool, s, paired, synthetic red; raveled commercial wool, red, recarded and respun with white commercial wool, z, synthetic pink. Selvages: warp and weft, 2 3-ply handspun indigo blue wool yarns. Corners: missing, but there are remains of fine 3-ply red yarns inserted to make tassels.

T.532 1875–1885, gift of Amelia E. White, 1954.

T.533 1880, gift of Amelia E. White, 1954.

T.534 1880–1890, gift of Amelia E. White, 1954.

T.543 1880–1890, gift of Margretta S. Dietrich, 1961.

T.544 1880–1890, gift of Margretta S. Dietrich, 1961.

T.547 1880–1890, gift of Margretta S. Dietrich, 1961.

T.548 1880–1890, gift of Margretta S. Dietrich, 1961.

T.555 1890–1900, gift of Margretta S. Dietrich, 1961.

T.558 1880–1890, gift of Margretta S. Dietrich, 1961.

T.560 1880–1890, gift of Margretta S. Dietrich, 1961.

T.561 1880–1895, gift of Margretta S. Dietrich, 1961.

T.562 1880–1890, gift of Margretta S. Dietrich, 1961.

T.566 1875–1880, gift of Margretta S. Dietrich, 1961.

T.567 1880–1890, gift of Margretta S. Dietrich, 1961.

T.569 Rug, 1890, gift of Margretta S. Dietrich, 1961.

T.571 1880–1890, gift of Margretta S. Dietrich, 1961.

T.572 1880–1890, gift of Margretta S. Dietrich, 1961.

T.614 1880, gift of Amelia E. White, 1952.

*T.615 (p. 72) 1880–1890, gift of Amelia E. White, 1952. 71" x 48" (180 x 122 cm). Warps: 9; handspun wool, z, natural white. Wefts: 32; handspun wool, z, natural white, brown, and gray, and synthetic coral and orange. Selvages and corners: restored.

T.616 1880, gift of Amelia E. White, 1952.

T.617 1880–1890, gift of Amelia E. White, 1952.

T.618 1880–1890, gift of Amelia E. White, 1952.

T.619 1880–1890, gift of Amelia E. White, 1952.

T.621 1880–1890, gift of Amelia E. White, 1952.

T.639 1880–1890, gift of Amelia E. White, 1953.

T.640 1875–1885, gift of Amelia E. White, 1953.

T.651 1890–1900, purchased from Ina Sizer Cassidy, 1961.

T.653 1880, gift of Kenneth Chapman, 1962; originally obtained in Las Vegas, New Mexico, in 1950s.

T.668 1890, gift of Mrs. Chandler Hale, 1962.

*T.670 (p. 58) 1870–1885, gift of Mrs. Chandler Hale, 1962. 74" x 47" (188 x 119 cm). Warps: 10; handspun wool, z, natural white. Wefts: 31; handspun wool, z, natural white, vegetal indigo blue and yellow-green, and synthetic red; commercial raveled wool, s, quadrupled, synthetic red. Selvages: warp and weft, 2 3z-S red handspun wool yarns. Corners: selvage yarns knotted, extra raveled red yarns inserted to make tassels.

T.671 1880–1890, gift of Mrs. Chandler Hale, 1962.

T.673 1880–1890, gift of Mrs. Chandler Hale, 1962.

T.674 1880–1890, gift of Mrs. Chandler Hale, 1964.

T.678 1875–1880, gift of Mrs. Chandler Hale, 1962.

T.688 1880–1890, gift of Mrs. E. B. Mason, 1963.

T.713 1865–1875, gift of Amelia E. White, 1965.

T.714 1865–1875, gift of Amelia E. White, 1965.

T.718 About 1875, gift of Mr. and Mrs. Fermor S. Church, 1966.

T.721 1880–1890, gift of Fermor S. Church, 1967.

1978-1-167 Rug, 1890, gift of Amelia E. White, 1978.

1978-1-169 1880–1890, gift of Amelia E. White, 1978.

MOQUI-PATTERN BLANKETS AND RUGS

T.10 1875–1885, gift of Mary Cabot Wheelwright, 1927.

T.103 1870–1880, gift of Amelia E. White, 1930.

*T.109 (p. 42) 1870–1880, purchased from Fred Harvey Indian Dept., 1930. 72" x 45" (183 x 114 cm). Warps: 8; handspun wool, z, natural white. Wefts: 25; handspun wool, z, natural brown and vegetal indigo blue; raveled commercial wool, z, synthetic pink (faded); handspun(?) wool, z, synthetic(?) red and green. Selvages and corners: restored.

*T.308 (p. 72) 1865–1875, purchased from George Bonin, 1936. 67" x 45" (170 x 114 cm). Warps: 8; handspun wool, z, natural white. Wefts: 36; handspun wool, z, natural white and brown, vegetal indigo blue and yellow-green; raveled commercial wool, s, grouped 2–4, presynthetic red; commercial wool, 3z-S, synthetic red. Selvages and corners: restored. Possibly a slave blanket.

T.397 1890–1900, purchased from H. C. Lockett, 1942. Woven as a rug.

T.432 1885–1895, gift of Amelia H. White, 1945. Germantown yarns, woven as a rug.

T.464 1870–1875, purchased from Laura Gilpin, 1945.

T.642 1885–1895, gift of Amelia E. White, 1963.

WEDGE WEAVE BLANKETS

T.6 1880–1890, purchased from Spanish and Indian Trading Co., 1927.

T.15 1890, purchased from Mary Hunter, 1927.

T.16 1880–1890, purchased from Dionico Ortega, 1927.

T.47 1880–1890, gift of Henry G. Stevens, 1928.

T.56 1880–1890, gift of Mary Cabot Wheelwright, 1929.

T.366 1880–1890, purchased from H. P. Mera, 1941.

T.367 1880–1890, purchased from H. P. Mera, 1941.

T.550 1880–1890, gift of Margretta S. Dietrich, 1961.

T.551 1880–1890, gift of Margretta S. Dietrich, 1961.

T.552 1880–1890, gift of Margretta S. Dietrich, 1961.

T.553 1880–1890, gift of Margretta S. Dietrich, 1961.

T.554 1880–1890, gift of Margretta S. Dietrich, 1961.

*1969-41 (p. 73) 1870–1880, gift of Amelia E. White, 1969. 48" x 32" (122 x 81 cm). Warps: 10; handspun wool, z, natural white. Wefts: 52; handspun wool, z, natural white, vegetal indigo dark blue, indigo blue-black, and vegetal(?) greenish-yellow; raveled commercial wool, paired or tripled, z, synthetic(?) red; raveled commercial wool, 3s-S, synthetic(?) red. Selvages: warp and weft, 2 3z-S indigo blue handspun wool yarns. Corners: warp and weft selvage yarns knotted separately, extra yarns inserted to make tassels.

SLAVE BLANKETS

T.21 1870–1880, purchased from W. A. Pope, 1928.

*T.189 (p. 77) 1860–1865, gift of Amelia E. White, 1931. 81" x 49" (206 x 124 cm). Warps: 7; handspun wool, z, natural white. Wefts: 39; handspun wool, z, natural white and black; raveled commercial wool, z, used in 6 strands, cochineal red. Selvages: warp, restored; weft, 2 3z-S handspun blue wool yarns. Corners: restored.

*T.333 (p. 59) About 1880, purchased by Ben G. Miller, 1939. 85" x 49" (216 x 125 cm). Warps: 7; handspun wool, 2z-S, natural white. Wefts: 31; handspun wool, z, natural white, gray, and brown, and synthetic red, blue, orange/gold, yellow, pale green, ivory, and lavender. Selvages and corners: restored.

T.341 1880, purchased from Spanish and Indian Trading Co., 1940.

T.342 1870–1880, purchased from Spanish and Indian Trading Co., 1940.

*T.343 (p. 59) 1870–1880, purchased from Old Santa Fe Trading Post, 1940. 75½" x 57" (192 x 145 cm). Warps: 7; commercial cotton, 4z-S, natural white. Wefts: 32; handspun wool, z, natural white and synthetic lavender, pink, red, green, yellow, orange, and blue. Selvages: warp and weft, 2 3z-S handspun white wool yarns. Corners: selvage yarns knotted.

T.363 About 1850, purchased from H. P. Mera, 1941.

T.570 About 1880, gift of Margretta S. Dietrich, 1961.

GERMANTOWN BLANKETS AND RUGS

T.28 Saddle blanket, 1880–1890, gift of E. S. Toelle, 1928.

T.37 Saddle blanket, 1880–1885, purchased from Spanish and Indian Trading Co., 1929.

T.63 Rug, 1895–1900, purchased from Fred Harvey, 1929.

T.64 Rug? 1880–1890, purchased from B. S. Swearingen, 1929.

*T.95 (p. 70) Blanket, 1885–1890, gift of J. E. Otis, 1930. 81" x 56" (206 x 142 cm). Warps: 10; commercial cotton, 4z-S, natural white. Wefts: 50; commercial wool, 4z-S, natural white and synthetic red, yellow, blue, green, and purple. Selvages: warp, 4 3z-S handspun red yarns; weft, restored. Corners: red yarns inserted to make tassels.

T.364 Blanket, 1881, purchased from H. P. Mera, 1941; originally made for a farmer in Ignacio, Colorado.

T.374 Rug, 1880–1890, gift of Mary Cabot Wheelwright, 1941.

T.407 Rug, 1880–1890, gift of Mrs. James R. Thorpe, 1944.

T.486 Rug, 1885–1890, purchased from Mrs. C. W. Kemp, 1952.

*T.489 (p. 82) Saddle throw, 1885–1890, gift of the Goulding-Morgan family, 1952. 25½" x 36" (65 x 91 cm). Warps: 13; handspun wool, z, natural white. Wefts: 34; commercial wool, 4z-S, natural white and synthetic red, green, purple, and yellow. Selvages: warp, 2 3-strand red yarns, each strand a 4z-S yarn; weft, 3 3z-S handspun brown yarns. Corners: heavy tassels of commercial 4z-S yarns and fringe along lower border in orange, green, tan, blue, and purple.

T.515 Rug, 1880–1890, gift of Amelia E. White, 1954.

*T.516 (p. 78) Rug or blanket, 1885–1895, gift of Amelia E. White, 1954. 48" x 33" (122 x 84 cm). Warps: 12; commercial cotton string, 4z-S, natural white. Wefts: 42; commercial wool, 4z-S, natural white and synthetic green, purple, yellow, red, and black. Selvages and corners: restored.

T.528 Blanket, 1875–1885, gift of Amelia E. White, 1954.

T.545 Saddle throw, 1885–1890, gift of Margretta S. Dietrich, 1961.

T.588 Rug, 1885–1895, gift of Amelia E. White, 1960.

T.638 Blanket, 1885–1890, purchased at Bluewater, NM.

T.725 Blanket, 1885–1895, purchased from May Yontz Estate, 1968.

1969-40 Saddle blanket, 1890–1908, gift of Amelia E. White, 1969.

1978-1-166 Blanket, 1880–1890, gift of Amelia E. White, 1978.

1984-4-63 Rug, 1880–1890, given in memory of Margaret Moses, 1984.

PICTORIALS

T.9 Blanket, 1880–1890, purchased from B. S. Swearingen, 1927.

*T.344 (p. 79) Blanket, 1880–1890, purchased from Old Santa Fe Trading Post, 1940. 75" x 53" (190 x 135

cm). Warps: 7; handspun wool, z, natural white. Wefts: 31; handspun wool, z, natural white and black, and synthetic light tan, olive green, and mottled purple-red. Selvages: warp, 2 3z-S synthetic coral handspun wool yarns; weft, 1 2z-S coral and 1 2z-S tan yarn, handspun wool. Corners: largely worn off.

T.405 Blanket, 1880–1890, purchased from Eleanor O. Brownell, 1944.

***T.472** (p. 114) Rug, 1949, purchased from Gilbert S. Maxwell, 1950. 68" x 50" (173 x 127 cm). Warps: 9; handspun wool, z, natural white. Wefts: 38; handspun wool, z, natural white and gray, and synthetic black, red, green, orange, and gold. Selvages: warp, 2 2z-S handspun white yarns; weft, 2 2z-S handspun synthetic red yarns. Corners: selvage yarns knotted, extra red yarns inserted to make tassels.

T.474 1950, gift of Gilbert S. Maxwell, 1950. Rug woven by Mary Francisco, Huerfano Trading Post, near Shiprock.

T.485 1950, gift of Gilbert S. Maxwell, 1951. Rug woven near Upper Greasewood.

T.580 Rug, 1950s, gift of Margretta S. Dietrich, 1961.

T.660 Rug, 1940–1950, gift of Mrs. Bob Martin, 1962.

T.727 Rug, 1968, purchased from Chaparral Trading Post, 1968.

***T.733** (p. 109) Rug, 1920–1930, purchased through Ella M. Schroeder, 1970. 99" x 53" (252 x 135 cm). Warps: 9; handspun wool, z, natural white. Wefts: 30; handspun wool, z, natural white, black, and gray, and synthetic red. Selvages: warp and weft, 2 2z-S handspun gray wool yarns. Corners: worn, one corner shows weft selvage yarns looped over warp selvage yarns, knotted.

***1963-4** (p. 71) Rug, 1895–1920, gift of Mr. and Mrs. Theodore Van Soelen, 1963. 66½" x 41½" (169 x 106 cm). Warps: 7; handspun wool, z, natural white. Wefts: 27; handspun wool, z, natural white and gray, and synthetic mottled red/brown, orange, and red. Selvages and corners: restored.

RUGS

T.17 1920–1927, gift of Clara E. Brentlinger, 1927.

T.31 1920–1940, purchased from Silviano Salazar, 1928.

T.97 1900–1920, gift of Amelia E. White, 1978.

T.174 1920–1925, gift of H. P. Mera, 1931.

T.190 About 1900, purchased from Julius Gans, 1931.

T.194 About 1900–1910, purchased 1932.

T.197 1890–1910, purchased 1932.

T.324 1920–1935, gift of H. P. Mera, 1938.

T.325 1930–1940, gift of H. P. Mera, 1938.

T.345 1900–1915, purchased from Spanish and Indian Trading Co., 1940.

T.353 1930–1940, purchased from C. Bland Jamison, 1941.

T.373 1920–1940, purchased from Mrs. M. E. Hallock.

***T.400** (p. 45) 1914, gift of Rose Dougan, 1943; originally purchased in Palm Springs, California, 1914. 80" x 80" (203 cm square). Warps: 9; commercial wool, 4z-S, natural white. Wefts: 39; handspun wool, z, synthetic black, red, brown, yellow, and orange, and synthetic(?) tan. Selvages: warp, 2 3z-S handspun red yarns; weft, 2 strands, each containing 3 4-ply commercial red wool yarns which have been tightly re-twisted. Corners: missing.

T.434 1920, gift of Amelia E. White, 1945.

T.493 1953, purchased from Laura Gilpin, 1953. Woven at Shonto, AZ.

T.504 1954, gift of Amelia E. White, 1954.

T.505 1940–1950, gift of Amelia E. White, 1954.

T.512 1920–1930, gift of Amelia E. White, 1961.

T.518 1920–1940, gift of Amelia E. White, 1954.

T.519 1890–1920, gift of Amelia E. White, 1961.

T.523 1940–1950, gift of Amelia E. White, 1954.

T.540 1940–1960, gift of Margretta S. Dietrich, 1961.

T.541 1940–1960, gift of Margretta S. Dietrich, 1961.

T.546 Saddle blanket, about 1900, gift of Margretta S. Dietrich, 1961.

T.549 1930–1940, gift of Margretta S. Dietrich, 1961.

T.556 1900–1920, gift of Margretta S. Dietrich, 1961.

T.557 1920–1930, gift of Margretta S. Dietrich, 1961.

T.559 1920–1930, gift of Margretta S. Dietrich, 1961.

T.563 1920–1930, gift of Margretta S. Dietrich, 1961.

T.565 1900–1920, gift of Margretta S. Dietrich, 1961.

T.574 1920–1930, gift of Margretta S. Dietrich, 1961.

T.575 1920–1925, gift of Margretta S. Dietrich, 1961.

T.576 1920–1940, gift of Margretta S. Dietrich, 1961.

T.577 1920–1930, gift of Margretta S. Dietrich, 1961.

T.578 1920–1940, gift of Margretta S. Dietrich, 1961.

T.579 1920–1930, gift of Margretta S. Dietrich, 1961.

T.581 1940–1960, gift of Margretta S. Dietrich, 1961.

T.582 1961, gift of Margretta S. Dietrich, 1961.

T.583 1961, gift of Margretta S. Dietrich, 1961.

T.652 1940–1950, purchased from Ina Sizer Cassidy, 1961.

T.665 1930–1940, gift of Laura Hersloff, 1963; originally purchased at Hubbell's Trading Post in the 1930s.

T.666 1930, gift of Laura Hersloff, 1963; originally purchased at Hubbell's Trading Post in the 1930s.

T.669 1930–1940, gift of Mrs. Chandler Hale, 1962.

T.672 1900–1914, gift of Mrs. Chandler Hale, 1962.

T.675 1900–1920, gift of Mrs. Chandler Hale, 1962.

T.676 1900–1930, gift of Mrs. Chandler Hale, 1962.

T.679 1900–1925, gift of Mrs. Chandler Hale, 1962.

T.680 1900–1920, gift of Mrs. Chandler Hale, 1962.

T.681 1910–1925, gift of Mrs. Chandler Hale, 1962.

T.703 1920–1930, gift of Mr. and Mrs. Gustave Baumann, 1964.

T.705 1940–1950, gift of Ina Sizer Cassidy, 1964.

T.720 1930–1940, gift of Nancy Fox, 1967.

T.732 1969, purchased from Indian Shop, Alvarado Hotel, 1969.

T.734 1950–1958, purchased through Mrs. Albert Schroeder, 1958.

T.736 About 1940, purchased from Mrs. Robert Morton, 1971. Alamo Navajo.

1969-36 1969, purchased from Chaparral Trading Post, 1969.

1978-1-85 1920–1940, gift of Amelia E. White, 1978.

1978-1-168 1920–1930, gift of Amelia E. White, 1978.

1978-1-170 1900–1920, gift of Amelia E. White, 1978.

1978-1-246 1910–1920, gift of Amelia E. White, 1978.

1978-1-250 1930–1940, gift of Amelia E. White, 1978.

1984-12-1 1930–1940, gift of Mary Henderson, 1984. Single saddle blanket size.

1984-12-2 1930–1940, gift of Mary Henderson, 1984. Single saddle blanket size.

RUGS OF RECOGNIZED STYLES

Hubbell Revival

T.107 1895–1910, purchased from Fred Harvey Indian Dept., 1930.

*T.108 (p. 86) 1895–1910, purchased from Fred Harvey Indian Dept., 1930. 80" x 56" (203 x 142 cm). Warps: 11; handspun wool, z, natural white. Wefts: 65; handspun wool, z, natural white, vegetal indigo blue/black, and vegetal(?) yellow; raveled wool, s, tripled, synthetic red. Selvages: warp and weft, 2 3-ply indigo blue handspun wool yarns. Corners: selvage yarns knotted, extra indigo blue yarns inserted to make tassels.

T.398 1895–1910, purchased from Mrs. Russell Cowles, 1943.

T.514 1885–1900, gift of Amelia E. White, 1954.

T.622 1895–1910, gift of Amelia E. White, 1963.

T.726 1895–1910, purchased from May Yontz Estate, 1968.

Ganado

*T.478 (p. 19) About 1950, purchased from Gilbert S. Maxwell, 1951. 64" x 45" (163 x 114 cm). Warps: 9; handspun wool, z, natural white. Wefts: 24–33; handspun, z, natural white and gray, and synthetic black and red. Selvages: warp and weft, 2 2z-S handspun synthetic lavender wool yarns. Corners: selvage yarns knotted to make tassels. Ganado-Klagetoh.

T.483 1950, purchased from Gilbert S. Maxwell, 1951.

*T.484 (p. 75) 1950, purchased from Gilbert S. Maxwell, 1951. 114" x 72" (290 x 183 cm). Warps: 9; handspun wool, z, natural white. Wefts: 33; handspun wool, z, natural white and gray, and synthetic black and

red. Selvages: warp and weft, 2 2z-S white handspun yarns. Corners: selvage yarns knotted to make tassels.

1978-1-14 1940–1950, gift of Amelia E. White, 1978.

1984-4-57 1920–1925, given in memory of Margaret Moses, 1984. Ganado-Klagetoh.

Early Crystals

T.697 1910–1920, gift of Mrs. Clyde Washburn, 1964. Abstract pictorial.

T.702 1920–1930, gift of Mr. and Mrs. Gustave Baumann, 1964.

1984-4-55 1910–1920, given in memory of Margaret Moses, 1984.

Two Grey Hills

T.68 1929, purchased from Gallup Mercantile Co., 1929.

***T.471** (p. 91) 1949, purchased from Gilbert S. Maxwell, 1950. 67½" x 45" (172 x 114 cm). Warps: 18; handspun, z, natural white. Wefts: 96–110; handspun wool, z, natural white, tan, and gray, natural(?) brown, and vegetal(?) black. Selvages: warp, 2 3z-S white handspun wool yarns; weft, 3 2z-S natural tan handspun wool yarns. Corners: selvage yarns tightly knotted to make tassels, corners roll in.

T.646 1950–1954, gift of Mr. and Mrs. Marshall McCune, 1954.

T.647 1950–1954, gift of Mr. and Mrs. Marshall McCune, 1954.

T.648 1950–1954, gift of Mr. and Mrs. Marshall McCune, 1954.

T.649 1950–1954, gift of Mr. and Mrs. Marshall McCune, 1954.

T.650 1950–1954, gift of Mr. and Mrs. Marshall McCune, 1954.

T.731 1968, purchased from Chaparral Trading Post, 1968.

1969-37 About 1950s, gift of Mr. and Mrs. Marshall McCune, 1969.

1969-38 About 1950, gift of Mr. and Mrs. Marshall McCune, 1969.

Storm Pattern

T.683 1950–1962, gift of Mrs. Chandler Hale, 1962.

***1969-45** (p. 92) 1960–1969, purchased from Al R. Packard, 1969. 60" x 32" (152 x 81 cm). Warps: 7; commercial cotton, S, multiple ply, natural white. Wefts: 22; handspun wool, z, natural white and gray, and synthetic black and red. Selvages: warp, 2 3z-S handspun black wool yarns; weft, none. Corners: warp selvage yarns knotted.

Chinle

T.207 1932, purchased from Spanish and Indian Trading Co., 1932.

***T.350** (p. 100) 1940, purchased from Spanish and Indian Trading Co., 1941. 64" x 42" (163 x 107 cm). Warps: 7; handspun wool, z, natural white. Wefts: 20–40, handspun wool, z, natural white and gray, vegetal yellow and gray-green, chrome(?) rust, unknown black and brown. Selvages: warp and weft, 2 2z-S synthetic dark blue handspun wool. Corners: selvage yarns knotted to make tassels.

T.394 1940, purchased from H. C. Lockett, 1942.

T.409 1944, purchased from Frank Packard, 1944.

T.431 1945, purchased from Bessie S. McKibbin, 1945

T.465 1940–1946, purchased from Chaparral Trading Post, 1946.

T.475 1950, purchased from Gilbert S. Maxwell, 1950.

T.481 1950, purchased from Gilbert S. Maxwell, 1951.

T.482 1950, purchased from Gilbert S. Maxwell, 1951.

T.499 1934, purchased from Elizabeth Elder, 1958; originally obtained at Chinle, Arizona, in 1934.

***1980-1-4** (p. 98) 1938, gift of Sallie R. Wagner, 1980; acquired from H. L. (Cozy) McSparron. 75" x 45½" (190 x 116 cm). Warps: 9; handspun wool, z, natural white. Wefts: handspun wool, z, natural white, and Dupont dye red, rust, and blue. Selvages: warp and weft, 2 2z-S handspun wool yarns in Dupont blue. Corners: selvage yarns knotted to make tassels.

1984-4-67 1930–1945, given in memory of Margaret Moses, 1984.

Wide Ruins

T.662 1957–1958, gift of Laura Hersloff, 1963; originally purchased in Gallup in 1957 or 1958.

1980-1-1 1939, gift of Sallie R. Wagner, 1980.

***1980-1-2** (p. 98) About 1946, gift of Sallie R. Wagner, 1980. Woven by Patsy Martin, one of a pair (see

1980-1-3). 71½" x 37" (182 x 93 cm). Warps: 8; handspun wool, z, natural white. Wefts: 27; handspun wool, z, natural white and gray, and vegetal gray-green, gold, coral, and ivory. Selvages: warp and weft, 2 2z-S coral handspun wool yarns. Corners: selvage yarns tightly knotted, corners roll over.

1980-1-3 About 1946, gift of Sallie R. Wagner, 1980. Woven by Patsy Martin, one of a pair (see 1980-1-2).

1982-8-1 1960–1970, gift of Mr. and Mrs. G. Akahoshi, 1982.

1984-11-1 1945–1950, gift of Sallie R. Wagner, 1984. Contains bands of diamond twill; resembles Coal Mine Mesa style.

1984-11-2 1945–1950, gift of Sallie R. Wagner, 1984.

Nazlini

***T.477** (p. 100) About 1950, purchased from Gilbert S. Maxwell, 1951. 73" x 45" (185 x 114 cm). Warps: 10; handspun wool, z, natural white. Wefts: 30; handspun wool, z, natural white and gray, natural(?) black, vegetal(?) maroon, synthetic(?) yellow, and synthetic red. Selvages: warp, 2 2z-S vegetal yellow handspun wool yarns; weft, 2 2z-S black handspun wool yarns. Corners: selvage yarns knotted to make tassels.

Modern Crystal

T.479 1950, purchased from Gilbert S. Maxwell, 1951.

T.480 1950, purchased from Gilbert S. Maxwell, 1951.

***T.729** (p. 99) 1960–1968, purchased from Chaparral Trading Post, 1968. Woven by Alice Begay. 70" x 44½" (178 cm x 113 cm). Warps: 8; handspun wool, z, natural white. Wefts: 28–30, handspun wool, z, natural white and gray, vegetal rust and yellow, and vegetal(?) black. Selvages: warp and weft, 2 2z-S natural gray handspun wool yarns. Corners: selvage yarns knotted to make tassels.

Teec Nos Pos–Red Mesa

***T.462** (p. 91) 1945, purchased from Farmington Mercantile Co., 1945. 78" x 49" (198 x 124 cm). Warps: 9; handspun wool, z, natural gray and white. Wefts: 28–30; handspun wool, z, natural white and gray, natural(?) black, and synthetic red, yellow, brown, turquoise, and orange. Selvages: warp, 2 2z-S natural brown handspun wool yarns; weft, 2 2z-S handspun black wool yarns. Corners: extra 2-ply black yarns inserted to make tassels.

***1984-4-64** (p. 94) 1950–1960, given in memory of Margaret Moses, 1984. 139" x 79" (353 x 201 cm). Warps: 12; handspun, z, natural white. Wefts: 28; commercial 2z-Z, natural gray and tan, and synthetic black, brown-red, maroon, dark blue, turquoise, orange, red, and rust. Selvages: warp, 3 strands twisted S, each composed of 3 2z-Z yarns, black; weft, same, but red. Corners: warp and weft yarns knotted to form tassels.

Raised Outline Style

***1969-35** (p. 102) 1969, purchased from Chaparral Trading Post, 1969. Woven by Desbah Begay. 61½" x 33½" (156 x 85 cm). Warps: 7; handspun wool, z, natural white. Wefts: 28–30; handspun wool, z, natural white and gray-brown, vegetal blue-gray, tan, and brown, and synthetic red and black. Selvages: warp and weft, 2 2z-S gray yarns. Corners: selvage yarns knotted.

1984-20-1 1950–1960, gift of Mr. and Mrs. Jack Lambert, 1984.

YEI, YEIBICHAI, AND SANDPAINTING RUGS

***T.114** (p. 96) Yeibichai rug, 1920–1930, gift of Amelia E. White, 1930. 52" x 50½" (132 x 128 cm). Warps: 9; handspun wool, z, natural gray. Wefts: 33; handspun wool, z, natural black and white, and synthetic brown, red, yellow, purple, green, and gold. Selvages: warp, 2 3z-S handspun gray wool yarns; weft, 2 2z-S handspun white wool yarns. Corners: selvage yarns knotted to make tassels.

***T.123** (p. 95) Sandpainting rug, 1925–1930, gift of Mary Cabot Wheelwright, 1930. 100" x 84" (254 x 213 cm). Warps: 10; handspun wool, z, natural white. Wefts: 47; handspun wool, z, natural brown and white, and synthetic red, yellow, blue, and black. Selvages: warp and weft, 2 3z-S light brown handspun wool yarns. Corners: selvage yarns knotted to make tassels.

T.387 Yeibichai rug, about 1940, purchased from Ina Sizer Cassidy, 1942.

***T.704** (p. 95) Sandpainting rug, about 1930, gift of Mr. and Mrs. Gustave Baumann, 1964. 88" x 50" (224 x 127 cm). Warps: 8; handspun wool, z, natural white. Wefts: 33, handspun wool, z, natural gray, black, and white, synthetic red, pink, purple, yellow, and brown; commercial 3z-S synthetic green. Selvages: warp and weft, 2 2z-S light red handspun wool yarns. Corners: worn off.

1983-14-4 Sandpainting rug, 1982, exchange with Maxwell Museum, 1983.

***1983-14-5** (p. 96) Sandpainting rug, 1982, exchange with Maxwell Museum, 1983. 50½" x 40" (128 x 102 cm). Warps: 11; handspun wool, z, natural white. Wefts: 48; commercial wool, 4z-Z, natural white and synthetic tan, blue, yellow, red, and black. Selvages: warp, 2 coarse z-S handspun white wool yarns; weft, no selvage yarns. Corners: extra white yarns inserted to make tassels.

1984-4-56 Yei rug, about 1940–1950, given in memory of Margaret Moses.

TWILLS AND OTHER MULTIPLE-HEDDLE WEAVES

T.27 Double saddle blanket, 1880–1895, gift of E. S. Toelle, 1928.

T.32 Rug, 1920–1930, purchased from Fred Leighton, 1928.

T.96 Saddle throw, 1900–1920, gift of J. E. Otis, 1930.

T.181 Double saddle blanket, 1900–1920, purchased from Old Santa Fe Trading Post, 1931; O.J. Crandall Collection.

T.222 Double saddle blanket or rug, 1900–1912, gift of Kenneth M. Chapman, 1932; originally collected at Acoma in 1912.

T.272 Saddle throw, 1870–1880, purchased 1933.

***T.393** (p. 74) Double weave rug, 1920–1940, purchased from H. C. Lockett, 1942. 53½" x 31" (136 x 79 cm). Warps: 10; handspun wool, z, natural white. Wefts: 10 (for each surface); handspun wool, z, natural white and gray, and synthetic black, brown, and red. Selvages: warp and weft, 2 2z-S handspun red yarns. Corners: selvage yarns knotted to make tassels.

***T.396** (p. 101) Rug, double saddle blanket size, 1942, purchased from H. C. Lockett, 1942. Woven by Mrs. Bare Bowman, Tohatchi, NM. 54½" x 35" (138 x 89 cm). Warps: 12; handspun wool, z, natural white. Wefts: 33, handspun wool, z, natural white, brown, and gray. Selvages: warp and weft, 3 2z-S handspun wool yarns, 2 brown, 1 white. Corners: selvage yarns knotted to make tassels.

T.414 Double saddle blanket, 1870–1880, purchased from Bessie S. McKibbin, 1944 (Gen. McKibbin collection).

T.415 Double saddle blanket, 1870–1880, purchased from Bessie S. McKibbin, 1944 (Gen. McKibbin Collection).

T.470 Two-faced weave rug, about 1930, purchased from Dane Neumann, 1949; originally obtained from Spanish and Indian Trading Co., 1934.

T.488 Saddle throw, 1920–1940, gift of the Goulding-Morgan family, 1952.

T.492 Double saddle blanket, 1930–1953, purchased from Juan Cate, 1953.

T.507 Double saddle blanket or rug, 1920–1940, gift of Amelia E. White, 1954.

T.508 Double saddle blanket, about 1900, gift of Amelia E. White, 1954.

T.509 Small saddle blanket? About 1900, gift of Amelia E. White, 1954.

T.510 Double saddle blanket or rug, 1900–1925, gift of Amelia E. White, 1954.

***T.537** (p. 80) Rug, double saddle blanket size, 1920–1940, gift of Margretta S. Dietrich, 1961. 53½" x 27" (136 x 69 cm). Warps: 9; handspun wool, z, natural white. Wefts: 25; handspun wool, z, natural gray, brown, and black, and synthetic red. Selvages: warp, 2 2-ply handspun red yarns; weft, 3 2-ply handspun red yarns. Corners: extra red yarns inserted to make tassels.

T.538 Rug, double saddle blanket size, 1920–1940, gift of Margretta S. Dietrich, 1961.

T.539 Single saddle blanket, 1930, gift of Margretta S. Dietrich, 1961.

T.542 Single saddle blanket, 1920–1930, gift of Margretta S. Dietrich, 1961.

T.597 Saddle cinch, 1880–1890, gift of Ina Sizer Cassidy, 1961.

***T.659** (p. 74) Two-faced weave blanket, about 1885, purchased from Mrs. Ernest T. Lone, 1962. 43" x 30" (109 x 76 cm). Warps: 12; commercial cotton string, 4z-S, natural white. Wefts: 48; handspun wool, z, synthetic red and yellow; commercial wool, 4z-S, natural white and synthetic blue, green, yellow, red, purple, and orange. Selvages: warp, 3 strands twisted Z, each strand commercial wool, 4z-S, synthetic red; weft, 2 strands twisted Z, each strand commercial wool, 4z-S, red. Corners: selvage yarns knotted, extra yarns inserted to make tassels.

T.664 Double saddle blanket, 1930–1940, gift of Laura Hersloff, 1963; purchased at Hubbell's Trading Post in 1930s.

T.715 Double saddle blanket, 1920–1940, gift of Amelia E. White, 1965.

T.722 Rug, 1920–1930, gift of Fermor S. Church, 1967.

T.728 Single saddle blanket, 1960–1968, purchased from Chaparral Trading Post, 1968.

T.730 Two-faced weave rug, 1968, purchased from Chaparral Trading Post, 1968; woven by Clara Henry, Chilchinbito, AZ.

T.735 Rug, 1960–1970, purchased from Mrs. Robert Morton, 1971.

1969-39 Rug, double saddle blanket size, 1930, gift of Amelia E. White, 1969.

1978-1-198 Rug, double saddle blanket size, 1920–1930, gift of Amelia E. White, 1978.

***1978-1-206** (p. 81) Saddle cinch, 1875–1890, gift of Amelia E. White, 1978. 21" x 4½" at center (53 x 12 cm). Warps: 26; commercial wool tightly respun, 4z-S, natural white. Wefts: 20; handspun wool, z, synthetic red; commercial wool, 4z-S, natural white. Selvages: warp, warp end loops extend at each end and would have encircled the iron rings, which are missing; weft, 2 2z-S handspun red wool yarns, like the weft yarns.

1978-1-248 Rug, double saddle blanket size, 1900–1920, gift of Amelia E. White, 1978.

1978-1-251 Rug, double saddle blanket size, 1920–1930, gift of Amelia E. White, 1978.

1978-1-360 Rug, 1920–1930, gift of Amelia E. White, 1978.

1981-1-13 Single saddle blanket, 1880–1900, collected by Ina Sizer Cassidy, 1962.

***1981-15-4** (p. 81) Saddle cinch, 1880-1900, gift of Barbara L. Cook, 1981. 29" including metal rings x 4½" (74 x 12 cm). Warps: 13; handspun coarse wool, 2z-S, natural white and gray and synthetic red; commercial wool, 4z-S, synthetic red. Wefts: 14; handspun coarse wool, 2z-S, synthetic red; handspun coarse wool, z, synthetic red, green, and white; commercial wool, 4z-S, synthetic blue. Selvages: warp, looped around iron rings at both ends; weft, 2 strands, one paired handspun white wool yarns, the other tripled handspun gray wool yarns.

PILE WEAVES

T.29 Saddle pad, 1920–1930, gift of E. S. Toelle, 1928.

T.83 Rug, 1920–1930, gift of Mary Cabot Wheelwright, 1929.

1963-5 Saddle pad, 1930–1940, gift of Amelia E. White, 1963.

References

AMSDEN, CHARLES AVERY

1949 *Navajo Weaving, Its Technic and History* (Albuquerque: University of New Mexico Press).

BAILEY, GARRICK A., AND ROBERTA G. BAILEY

1982 *Historic Navajo Occupation of the Northern Chaco Plateau*, Navajo Indian Irrigation Project Contract NOO C 1420 8136 (Tulsa: University of Tulsa, Faculty of Anthropology).

BENNETT, KATHLEEN

1981 "Navajo Chief Blankets: A Trade Item Among Non-Navajo Groups," *American Indian Art* 7: 62–69.

BENNETT, NOEL

1974 *The Weaver's Pathway: A Clarification of the "Spirit Trail" in Navajo Weaving* (Flagstaff: Northland Press).

1979 *Designing with the Wool: Advanced Techniques in Navajo Weaving* (Flagstaff: Northland Press).

BERLANT, ANTHONY, AND MARY HUNT KAHLENBERG

1977 *Walk in Beauty: The Navajo and Their Blankets* (Boston: New York Graphic Society).

BOBB, BILL, AND SANDE BOBB

1983 Revised edition of *Navajo Rugs, Past, Present, and Future*, by Gilbert S. Maxwell (Santa Fe: Heritage Art).

BRODY, J. J.

1976 *Between Traditions* (Iowa City: University of Iowa Museum of Art).

BRUGGE, DAVID M.

1980 *A History of the Chaco Navajos*, Reports of the Chaco Center, 4 (Albuquerque: National Park Service).

1983 "Navajo Prehistory and History to 1850," in *Handbook of North American Indians*, vol. 10, ed. Alfonso Ortiz (Washington, D.C.: Smithsonian Institution).

BRYAN, NONABAH G., AND STELLA YOUNG

1940 *Navajo Native Dyes*, Indian Handcraft Series, Number 2 (Washington, D.C.: Education Division, U.S. Office of Indian Affairs).

DOUGLAS, FREDERIC H.

1951 "Navajo Wearing Blankets," *Indian Leaflet Series*, no. 113 (Denver Art Museum).

DUTTON, BERTHA P.

1961 *Navajo Weaving Today* (Santa Fe: Museum of New Mexico Press).

EMERY, IRENE
1966 *The Primary Structures of Fabrics* (Washington, D.C.: The Textile Museum).

ERICKSON, JON T., AND THOMAS H. CAINE
1976 *Navajo Textiles from the Read Mullan Collection* (Phoenix: The Heard Museum).

FISHER, NORA, AND JOE BEN WHEAT
1979 "The Materials of Southwestern Weaving," in *Spanish Textile Tradition of New Mexico and Colorado*, Museum of International Folk Art (Santa Fe: Museum of New Mexico Press).

GALVIN, JOHN, ED.
1970 *Through the Country of the Comanche Indians in the Fall of the Year 1845, A Journal of a U.S. Army Expedition Led by Lt. James W. Abert* (San Francisco: John Howell—Books).

GREGG, JOSIAH
1962 *Commerce of the Prairies: The 1844 Edition Unabridged* (Philadelphia and New York: J. B. Lippincott Co.).

HATCHER, EVELYN PAYNE
1974 *Visual Metaphors: A Formal Analysis of Navajo Art*, The American Ethnological Society, monograph 58 (St. Paul: West Publishing Co.).

HEDLUND, ANN LANE
1983 "Contemporary Navajo Weaving: An Ethnography of a Native Craft" (Ph.D. diss., Department of Anthropology, University of Colorado).

HEGEMANN, ELIZABETH COMPTON
1963 *Navajo Trading Days* (Albuquerque: University of New Mexico Press).

HESTER, JAMES J.
1962 *Early Navajo Migrations and Acculturation in the Southwest*, Museum of New Mexico Papers in Anthropology, no. 6 (Santa Fe).

HILL, W. W.
1940 "Some Navaho Culture Changes During Two Centuries (With a Translation of the Early Eighteenth-Century Rabal Manuscript)," in *Essays in Historical Anthropology of North America*, Smithsonian Miscellaneous Collections 100 (Washington, D.C.: Smithsonian Institution).

HUBBELL, J. L.
ca. 1902 "Navajo Blankets and Indian Curios: Catalogue and Price List. Ganado, Apache County, Arizona" (Chicago: Press of Hollister Brothers).

JAMES, GEORGE WHARTON
1927 *Indian Blankets and Their Makers* (Chicago: A. C. McClurg & Co.; first published 1914). Reprint, 1970 (Glorieta, N.M.: Rio Grande Press).

JAMES, H. L.
1976 *Posts and Rugs: The Story of Navajo Rugs and Their Homes* (Globe, Ariz.: Southwest Parks and Monuments Association).

KAHLENBERG, MARY HUNT, AND ANTHONY BERLANT

1972 *The Navajo Blanket* (New York: Praeger Publishers, Inc.)

KENT, KATE PECK

1957 "The Cultivation and Weaving of Cotton in the Prehistoric Southwestern United States," *Transactions of the American Philosophical Society*, n.s. vol. 47, part 3 (Philadelphia: American Philosophical Society).

1961 *The Story of Navajo Weaving* (Phoenix: The Heard Museum).

1965 "Gobernador Textiles: Appendix II," in Eighteenth-Century Navajo Fortresses of the Gobernador District, by Roy L. Carlson. Series in Anthropology no. 10, Earl Morris Papers no. 2 (Boulder: University of Colorado Museum).

1966 "Archaeological Clues to Early Historic Navajo and Pueblo Weaving," *Plateau* 39:40–46. (Flagstaff: Museum of Northern Arizona).

1979 "An Analysis of Textile Materials from Walpi Pueblo," in *Walpi Archaeological Project Phase II*, vol. 6, part I. (Flagstaff: Museum of Northern Arizona). Restricted document.

1981 "From Blanket to Rug: The Evolution of Navajo Weaving after 1880," *Plateau* 52:4 (Flagstaff: Museum of Northern Arizona).

1983a "Spanish, Navajo, or Pueblo? A Guide to the Identification of Nineteenth-Century Southwestern Textiles," in *Hispanic Arts and Ethnohistory in the Southwest*, ed. Marta Weigle with Claudia Larcombe and Samuel Larcombe (Santa Fe: Spanish Colonial Arts Society).

1983b *Prehistoric Textiles of the Southwest*, School of American Research Southwest Indian Arts Series (Albuquerque: University of New Mexico Press).

1983c *Pueblo Indian Textiles: A Living Tradition* (Santa Fe: School of American Research Press).

LETTERMAN, JONATHAN

1856 "Sketch of the Navajo Tribe of Indians, Territory of New Mexico," in *Tenth Annual Report of the Smithsonian Institution* (Washington, D.C.).

MACLEISH, KENNETH

1940 "Notes on Hopi Belt-Weaving at Moenkopi," *American Anthropologist* n.s. 42:291–310.

MATTHEWS, WASHINGTON

1884 "Navajo Weavers," *Annual Report of the Bureau of American Ethnology* 3:371–91 (Washington, D.C.: Smithsonian Institution).

1900 "A Two-faced Navaho Blanket," *American Anthropologist* n.s. 2:638–42.

MAXWELL, GILBERT

1963 *Navajo Rugs, Past, Present, and Future* (Palm Desert, Calif.: Best-West Publications). Reprint, 1983, with additions by Bill and Sande Bobb (Santa Fe: Heritage Art).

McGREEVY, SUSAN BROWN

1982 *Woven Holy People: Navajo Sandpainting Textiles* (Santa Fe: Wheelwright Museum of the American Indian).

McNITT, FRANK

1957 *Richard Wetherill: Anasazi* (Albuquerque: University of New Mexico Press).

1962 *The Indian Traders* (Norman: University of Oklahoma Press).

MERA, H. P.

1947 *Navajo Textile Arts* (Santa Fe: Laboratory of Anthropology). Reprint, 1975, with additions by Roger and Jean Moss (Salt Lake City: Peregrine Smith, Inc.).

1949 *The Alfred I. Barton Collection of Southwestern Textiles* (Santa Fe: San Vicente Foundation).

MILLS, GEORGE

1959 *Navajo Art and Culture* (Colorado Springs: The Taylor Museum).

MOORE, J. B.

1911 "The Navajo," privately published catalogue, Crystal, N.M.

NEWCOMB, FRANC JOHNSON

1964 *Hosteen Klah: Navaho Medicine Man and Sand Painter* (Norman: University of Oklahoma Press).

PENDLETON, MARY

1974 *Navajo and Hopi Weaving Techniques* (New York: Collier Books).

PEPPER, GEORGE

1902 "The Making of a Navaho Blanket," *Everybody's Magazine*, January.

1923 "Navajo Weaving," unpublished manuscript located in the Latin American Library, Tulane University.

REICHARD, GLADYS A.

1934 *Spider Woman: A Story of Navajo Weavers and Chanters* (New York: McMillan). Reprint, 1968 (Glorieta, N.M.: Rio Grande Press).

1936 *Navajo Shepherd and Weaver* (New York: J. J. Augustin).

1939 *Dezba: Woman of the Desert* (New York: J. J. Augustin). Reprint, 1971 (Glorieta, N.M.: Rio Grande Press).

RODEE, MARIAN.

1977 *Southwestern Weaving* (Albuquerque: University of New Mexico Press).

1981 *Old Navajo Rugs, Their Development from 1900 to 1940* (Albuquerque: University of New Mexico Press).

ROESSEL, RUTH

1983 "Navajo Arts and Crafts," in *Handbook of North American Indians*, vol. 10, ed. Alfonso Ortiz (Washington, D.C.: Smithsonian Institution).

SCHAAFSMA, CURTIS F.

1978 "Archaeological Studies in the Abiquiu Reservoir District," *Discovery* (Santa Fe: School of American Research).

SHUFELDT, R. W.

1891 "The Navajo Belt-Weaver," *Proceedings* 14:391–94 (Washington, D.C.: United States National Museum).

SIEBER, ROY

1971 "The Aesthetics of Traditional African Art," in *Art and Aesthetics in Primitive Societies*, ed. Carol F. Jopling (New York: E. P. Dutton & Co., Inc.).

SIMMONS, KATINA

1977 "Oriental Influences in Navajo Rug Design," in *Ethnographic Textiles of the Western Hemisphere*, ed. Irene Emery and Patricia Fiske, Irene Emery Roundtable on Museum Textiles (Washington, D.C.: The Textile Museum).

STOLLER, IRENE PHILIP

1977 "The Revival Period of Navajo Weaving," in *Ethnographic Textiles of the Western Hemisphere*, ed. Irene Emery and Patricia Fiske, Irene Emery Roundtable on Museum Textiles (Washington, D.C.: The Textile Museum).

STOLLER, MARIANNE L.

1979 "Spanish Americans, Their Servants and Sheep: A Culture History of Weaving in Southern Colorado," *in Spanish Textile Tradition of New Mexico and Colorado*, Museum of International Folk Art (Santa Fe: Museum of New Mexico Press).

TANNER, CLARA LEE, AND CHARLIE R. STEEN

1955 "A Navajo Burial of About 1850," *Panhandle-Plains Historical Review* 28:110–18.

WHEAT, JOE BEN

1974 *Navajo Blankets from the Collection of Anthony Berlant* (Tucson: University of Arizona Museum of Art).

1975 "Foreword," in *Navajo Pictorial Weaving*, by Charlene Cerny (Santa Fe: Museum of New Mexico).

1976a "Navajo Textiles," in *The Fred Harvey Fine Arts Collection*, ed. Byron Harvey (Phoenix, Ariz.: The Heard Museum).

1976b "Spanish-American and Navajo Weaving, 1600 to Now" in *Collected Papers in Honor of Marjorie Ferguson Lambert*, Papers of the Archaeological Society of New Mexico, no. 3.

1976c "The Navajo Chief Blanket," *American Indian Art* 1:44–53.

1977 "Documentary Basis for Material Changes and Design Styles in Navajo Blanket Weaving," in *Ethnographic Textiles of the Western Hemisphere*, ed. Irene Emery and Patricia Fiske, Irene Emery Roundtable on Museum Textiles (Washington, D.C.: The Textile Museum).

1979 "Rio Grande, Pueblo, and Navajo Weavers: Cross Cultural Influence," in *Spanish Textile Tradition of New Mexico and Colorado*, Museum of International Folk Art (Santa Fe: Museum of New Mexico Press).

WITHERSPOON, GARY

1977 *Language and Art in the Navajo Universe* (Ann Arbor: University of Michigan Press).

WRIGHT, BARTON

1979 *Hopi Material Culture* (Flagstaff: Northland Press and the Heard Museum).

Index

References to illustrations are in italics.

6850